The
TRUE STORY OF
TOM DOOLEY

The
TRUE STORY OF
TOM DOOLEY

*From Western North Carolina Mystery
to Folk Legend*

JOHN EDWARD FLETCHER, PhD

Charleston London

THE
History
PRESS

Published by The History Press
Charleston, SC 29403
www.historypress.net

Copyright © 2013 by John Edward Fletcher, PhD
All rights reserved

First published 2013

Manufactured in the United States

ISBN 978.1.62619.043.6

Library of Congress CIP data applied for.

Contents

FOREWORD

The story of Tom Dooley has been, over the years, a blend of fact and fiction. It is a story that holds a fascination to all who hear it, and so often more facts and fiction have been added. In his book, Dr. Fletcher digs deeper into his family history to find the truth that has been imbedded in this legend that has found worldwide attention. Being so closely related to the Foster and Melton families, Dr. Fletcher has the advantage of finding the true facts. Even today, the story of Tom Dula, Ann Melton and Laura Foster will continue to stir the imaginations of writers who hope to solve the mystery of this oft-told story.

EDITH MARIE FERGUSON CARTER
Curator and Owner/Operator
Whippoorwill Academy and Village and Tom Dula Museum
Ferguson, North Carolina

Acknowledgements

In the immortal words of Albert Einstein, which I paraphrase here, "If I have seen more than others who have written on this matter, it is because I have stood on the shoulders of giants." This story could not have been written without the aid and cooperation of numerous other individuals with an interest in this Wilkes County, North Carolina legend. I have attempted to cite the important references about which I am aware concerning this story. In particular, I am indebted to my many North Carolina cousins for their contributions; to Tony W. Foster for the genealogy of the Foster families; to Wayne Monroe for his research on the Dula and Triplett families; to Edith F. Carter of the Whippoorwill Academy and Tom Dooley Museum; to Dr. John Hawkins of Caldwell County for cooperating on much of the research and exchanges on the Allison, Foster, Dula and Triplett interconnections; to my brother Robert W. Fletcher, who did a lot of the local legwork on locations, photographs and running down our family connections to the story; to James Terry Melton for his access to the Melton Family Histories; and to many other unnamed individuals who responded to my requests for documented information.

Essential resources were the Internet sites of Faye Moran, "Coming Home to History, Wilkes County," the Internet Resources of Ancestry, Family Search of the Latter-Day Saints Church; and, of course, the landmark books of the now deceased John Foster West. In particular, the resources, photos and illustrations from the Tom Dula Museum in the Whippoorwill Village were invaluable in writing this history. Other specific resources are cited where their data are used and discussed.

Lastly, I wish to thank Tony Foster, Tom Foster, Robert Fletcher and Terry Melton for their contributions and cooperation in completing and installing the final marker for the "Eternal Triangle," which now marks the graves of the principals in *The True Story of Tom Dooley*. In particular, Robert "Bob" Fletcher and James "Terry" Melton are acknowledged and thanked for their extensive work in the restoration of the Old Melton Cemetery, where Ann Melton is buried.

Any misquotes, mistakes or otherwise incorrect information herein are the responsibility of the author.

In the preparation of this manuscript, I wish to thank Leah Davis for graphic arts work and for her dedication to detail in its final presentation and my wife, Carol Fletcher, for helping read and correct the many drafts of the manuscript.

INTRODUCTION

Wilkes County, North Carolina. The year is 1865.

This is a factual retelling of the nation's first nationally publicized crime of passion and the true story behind the ballad that was the number one song by the Kingston Trio in 1958 and is still known and sung today. *The True Story of Tom Dooley* also details the various interconnected families whom the legend affected. It is told, not as the various legends and songs tell it, but as recounted in articles from contemporary newspapers, from the transcripts of the trial documents that remain and from other public records. More than one hundred witnesses gave testimony before the grand jury, and eighty-three were called for Tom Dula's first trial. Of those who testified during the two trials against "Tom Dooley," written records of only about twenty of those witnesses remain today. Besides those, the summaries of the trial testimony that were made by two different judges and the statements written by the prosecution and defense attorneys make up the remaining official records.

This history may not be the whole story—and possibly not the entire true story thanks to the passage of time. Some of the testimony is dubious at best, if not complete lies, and some of the testimony is contradictory, therefore it cannot all be true. The first part of this history gives the background and details up to the time that Laura Foster disappeared, and then it follows with a description of the few months after she went missing, the story of how her body was found and, finally, the trials and situations affecting the final outcomes.

The circumstantial evidence will be discussed, and the various events will be placed in a proper perspective of the "true story." It is hoped that the facts are detailed, the myths debunked and the mistakes present in other accounts corrected here.

This is not a novel, and there is no fiction written here. Where the facts are not established or are inconclusive, alternative scenarios are presented to explain what might have happened. In that sense, this is truly *The True Story of Tom Dooley*.



Chapter 1

THE MURDER OF LAURA FOSTER

HISTORY AND THE LEGEND


Chapter 1

THE MURDER OF LAURA FOSTER

HISTORY AND THE LEGEND

There have been many stories, books, articles and even a movie and a play written about the Wilkes County murder allegedly committed by Thomas Caleb Dula. After all that publicity, do we really know who "Tom Dooley," the man, was and how he came to be involved in this affair? The stories told and retold in the Hill Country and in Happy Valley of the Yadkin River are filled with myths, distortions and superstitions that often creep into local folklore and the verbal retelling of local events.

One notable example is the story often repeated by the blind balladeer and popular ballad singer Doc Watson, whose great-grandmother (Betty Triplett Watson) supposedly attended to Mrs. Ann Melton on her deathbed. Doc states in one of his recordings that there were really two men involved: a man named Grayson and Tom Dula. Grayson supposedly was in love with Laura Foster and helped track down Tom Dula after she was murdered. The truth is that Lieutenant Colonel James William Monroe Grayson never met Laura Foster but did employ the fugitive Tom Dula under the false name of "Tom Hall," as he called himself, at his plantation in Trade, Tennessee. Colonel Grayson helped arrest Tom Dula when the posse from Wilkes tracked the fugitive to his farm.

Another reason this story has persisted in popular folklore in Wilkes County, North Carolina, and received national attention from the *New York Herald* newspaper in New York is that it immediately followed the Civil War

and provided an opportunity for the Northern press to further denigrate the conquered peoples of the Southern Confederacy. Furthermore, the story was propagated in poem and song and became a national favorite when, in 1958, the Kingston Trio made "The Ballad of Tom Dooley" a hit song that remained internationally popular well into the 1990s. But who were the Wilkes County Dulas, and how did Tom Dula become involved with the Hill Country beauties Laura Foster and Ann Foster Melton?

THE BEGINNING

In the lower end of the Happy Valley after the Civil War, there were only about forty families, with a population of about 280 people; of those, 90 were black (mostly ex-slaves), and 189 were white. Only about 125 of these people owned all the land. The remaining 65 were tenant farmers who occasionally changed their tenant locations. All the landowners were closely bound together by kinship and marriage. The largest landowner in Happy Valley had been Captain William Dula, a Revolutionary War hero who died in 1835. His descendants were the Dulas, the Joneses, the Witherspoons and the Hortons, all of whom inherited his lands.

The South after the Civil War was a desolate place. Towns had been gutted, plantations burned, fields and crops burned or neglected and bridges and roads destroyed. The plantation owners (Southerners) were stripped of their slaves through Emancipation and stripped of the capital they had invested in now worthless Confederate bonds and currency. More than 258,000 Confederate soldiers had died in the war, and thousands more (perhaps as many as one million more) returned home wounded and/or sick. Many families had to rebuild their fortunes and lives without the help of adult males. Many white Southerners faced starvation and homelessness.

The Northern forces and the U.S. government kept troops in the South to preserve order, to govern and to protect the freed slaves from 1865 to 1868 or later. On the night of April 14, 1865, a Southern man named John Wilkes Booth assassinated President Abraham Lincoln. Booth had been obsessed with the Southern (Confederate) cause. The North and the Lincoln administration blamed the South and its leaders for Lincoln's death and speculated on a wider conspiracy of the unrepentant leaders of the defeated South. It was this atmosphere of oppression and retribution that prevailed in North Carolina within the Second Military Occupation District, to which

North Carolina was assigned by the occupying military forces. In 1866, North Carolina had not yet been readmitted to the Union; thus, it was without a valid state government and had basically lawless and unrepresented regions in many areas of the state. It was not until late 1868 that North Carolina was again admitted to the Union. This was the atmosphere of oppression and despair that Tom Dula, James Melton and other returning Confederate POWs found when they returned from their POW camps in Maryland and other Northern states.

This story takes place in the area around the small settlement of Elkville (near today's Ferguson) in Wilkes County, in the western foothills of North Carolina. Elkville was situated about fifteen miles east of the county seat in Wilkesboro. The Yadkin River runs through the area, and part of the Yadkin River Valley between Ferguson and Patterson was (and still is) known as Happy Valley. Wilkes County was founded in 1777, and when the first Dulas came to Happy Valley from Virginia, a few years after the American Revolutionary War, they settled along the Yadkin River and in the hills around the valley.

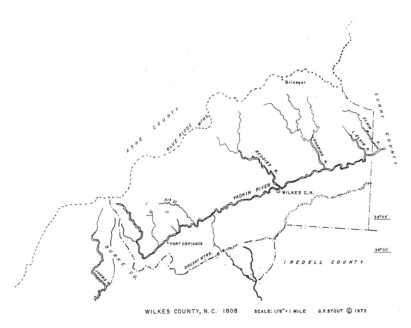

A map of Wilkes County, North Carolina, and the Yadkin River Valley home of the Dulas in 1808. *Courtesy of the Caldwell County Library.*

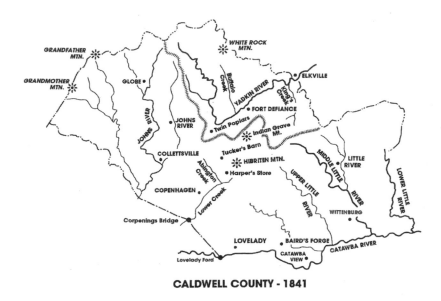

CALDWELL COUNTY - 1841

A map of Caldwell County, North Carolina, the home county of Laura and Wilson Foster, James Isbell and Dr. G.N. Carter, in 1841. *Courtesy of the Caldwell County Library.*

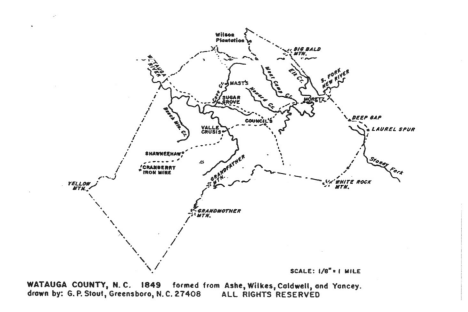

WATAUGA COUNTY, N.C. 1849 formed from Ashe, Wilkes, Caldwell, and Yancey.
drawn by: G. P. Stout, Greensboro, N.C. 27408 ALL RIGHTS RESERVED

A map of Watauga County, North Carolina, the home county of Pauline Foster, in 1849. *Courtesy of the Caldwell County Library.*

In 1841, parts of the county—where most of the Dulas lived—were detached from Wilkes County and added to parts of Burke County to form a new county called Caldwell. Eight years later, in 1849, more parts of Wilkes County, together with parts of the newly established Caldwell County, Ashe County and Yancey County, were combined to form Watauga County. This new county formation meant that some of the people involved in the case had lived in three different counties—Wilkes, Caldwell and now Watauga—even though they had never moved from their original homes.

In 1866, when the events being described here took place, contemporary papers claim that the inhabitants of Happy Valley were divided into two distinct and separate classes. In the lower end of the valley, close to the river, lived the wealthier planters or farmers, with large plantations and lots of employees (ex-slaves and tenant farmers). Before the Civil War, slave labor was used on the larger plantations, but after the war, plantation owners employed people from the other class in the area. These people were called "tenant farmers" and were less affluent; they lived in the hills mostly west of the river and valley. The *New York Herald* put it this way in an article published on May 2, 1868, the day after Tom Dula's execution:

> *The community in the vicinity of this tragedy is divided into two entirely separate and distinct classes. The one occupying the fertile lands adjacent to the Yadkin River and its tributaries, is educated and intelligent, and the other, living on the spurs and ridges of the mountains, is ignorant, poor and depraved. A state of immorality unexampled in the history of any country exists among these people, and such a general system of freeloveism prevails that it is "a wise child that knows its father."*

This report seems to have been significantly exaggerated, but what is correct is that there actually were two classes of people in the area. However, they were not as distinct and separate as the reporter suggested. In fact, most people were related by either blood or marriage. It is certain that some of the educated people would have been immoral and that many of the poorer people were just as intelligent, though most were uneducated. The reporter likely did not go among the Hill Country folks and only reported a New York carpetbagger's view of the recently conquered Southern peoples. Note that the Civil War had just ended, and North Carolina and Wilkes County were still under the control of a military governor, General John Schofield, in Military District Number 2. North Carolina was divided into three regions, with General Jacob D. Cox having jurisdiction over

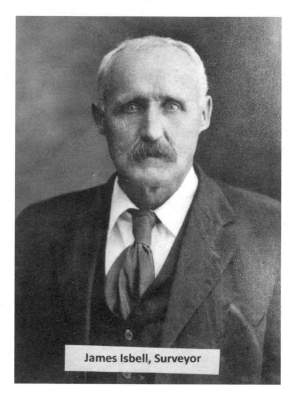

James Isbell, Surveyor

Colonel James Isbell, the relentless pursuer of Tom Dula and Ann Melton. *Courtesy of WV/TDM.*

Western North Carolina. A civilian governor, William W. Holden, was appointed by the Lincoln administration to govern the state, and most of the previously "elected" officials were barred from holding public office. The role local politics may have played in the Tom Dula trials will be discussed in a later chapter.

One of the Dulas who settled in the Yadkin Valley was Captain William Dula, a Revolutionary War officer and hero. His land was the richest in the valley. His brother, Bennett J. Dula, also settled in the area and claimed land—some in the valley but most in the hills to the west of the river. It was from these two brothers that both the less-affluent Dulas in the hills and the better-to-do Dulas who lived in the valley descended. Thomas Caleb Dula (Tom Dooley) was Bennett J. Dula's grandson, while his tenacious pursuer, Colonel James M. Isbell, was related to Captain William Dula by marriage to one of his granddaughters. James Isbell's father-in-law was Major David Eagles Horton, one of Captain William Dula's sons-in-law. Thus, Tom Dula and James Isbell were distant cousins but not actually blood related. James Isbell was about five or six years older than his cousin Tom Dula, and he was a descendant of Benjamin Howard, one of the original settlers of Wilkes County. James Isbell seemed obsessed with the capture and conviction of Tom Dula for reasons explained later.

Local Connections

Thomas Caleb Dula (aka Tom Dooley) and Angeline Pauline Triplett (aka Ann Foster) grew up as neighbors, living about half a mile from each other on the banks of Reedy Branch (not far from and almost parallel to present-day Bill Horton Road), which is a small tributary of the Yadkin River. Ann grew up with her mother and siblings, the family likely having been abandoned by her father, Francis Triplett, when Ann was about six. Francis's mother was Nancey Brown Triplett, and Carlotta and her children—Pinkney Andrew, Angeline Pauline and Thomas—were living with Nancey's parents in 1850.

Thomas Dula grew up with both his parents and his siblings, but in 1854, when Tom was about ten years old, his father, Thomas P. Dula, died. The family consisted of three daughters and three sons, Tom being the youngest of the group. The older sons were William L. and John R. Dula, and the daughters were Sarah C., Anna Evaline and Eliza. Tom and Ann were not just acquaintances but from an early age apparently knew each other "very well." They may have begun a sexual relationship at about the ages of thirteen and fourteen (Ann being one year older than Tom). Both teens had lost the father figure in their homes, but both had older brothers.

In 1859, at the age of sixteen, Angeline Triplett (Ann Foster) married the twenty-one-year-old James Gabriel Melton. During the later trial of Tom Dula, Ann's mother, Carlotta "Lotty" (Triplett) Foster, testified that she once found Ann and Tom in bed together, "about two years before the war" but after Ann's marriage to James Melton. So the marriage apparently did not end the relationship between Ann and Tom. However, the more likely time frame of this incident was in 1861, after James enlisted in the Confederate army and had left Ann home alone with their first child. Before that, Ann was pregnant with her first child and was not likely to have been looking to resume a sexual relationship with Tom. This was about two years before the North Carolina troops actively entered the war.

In May 1861, North Carolina finally seceded and joined the Confederacy, and a lot of men from Wilkes and its neighboring counties enlisted or were conscripted into the Confederate army. Tom's two older brothers, John R. Dula and William L. Dula, had enlisted in the Confederate army. A John Dula, age twenty-six, is listed in the 1860 census with Tom's mother, Mary. William L., age thirty-one, is listed in his own separate household with his new wife, Lucinda C. Walsh. Neither of these Dula sons survived the war. John

died of pneumonia in early 1862, and William died at the end of the war, in 1865, in a Maryland POW camp, reportedly of typhoid fever. Thomas, at only age seventeen, also joined the Confederate army but had to lie about his age. He was enrolled in Company K, Forty-second North Carolina Infantry

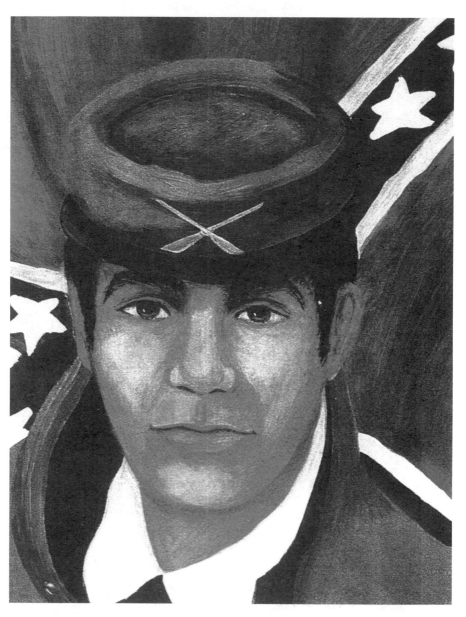

Edith Carter's illustration of Confederate soldier Thomas C. Dula. *Courtesy of the Whippoorwill Academy, Tom Dula Museum, Ferguson, North Carolina.*

Regiment, as a private. This particular company was formed with a lot of other men from Wilkes County who would later become involved in the Tom Dooley murder case.

From the trial records, we learn that George Washington Anderson, one of the defense witnesses, had served with Tom in the Forty-second Regiment, but there were many others. Among these were James Scott, husband of witness Celia (Anderson) Scott. Celia was the sister of George Washington Anderson. Tom's first cousin, William Leander Dula; his second cousin, William Carson Dula; Gay Hendricks; Leander Hendricks; Hezekiah Kendall; and Jesse Gilbert all were witnesses for the prosecution and also served in Company K. James Foster, who may very well have been the younger brother of murder victim Laura Foster, served in Company K, as did several other Hendrixes, Griffins, Gilberts, Halls, Scotts, Kendalls and Tripletts, all of them living in the general area around Happy Valley. Most of them were privates, but James Scott ended the war as a corporal.

Tom Dula was promoted to musician (drummer) and, according to Confederate records, served bravely until he was taken prisoner near the Neuse River during the Battle of Wyse's Fork, North Carolina, on March 10, 1865. However, his record shows several admittances to the hospital or being reported ill at muster. He seems to have contracted typhoid or a

Tom Dula's certificate of POW release. *Courtesy of the Wilkes Heritage Museum.*

Tom Dula's oath of allegiance certificate. *Courtesy of the Wilkes Heritage Museum.*

persistent fever that frequently incapacitated him. He spent the final few months of the war in Camp Hammond, a Union POW camp in Point Lookout, Maryland. On June 15, 1865, he swore an oath of allegiance to the Union and was released.

It is assumed that Tom returned to Elkville immediately after his release. Sometime after his return, he and Ann resumed their relationship. They still lived rather close to each other, and since neither of them engaged in work, they had a lot of opportunities to meet outside (which they did), but they probably also slept together in Ann Melton's home, whether or not James was there. Ann Pauline Foster, a distant cousin of Ann Melton's who was living with the Meltons, testified that Tom would sometimes sleep in the bed with James Melton until he was sure he was asleep, and then, on occasion, he would get into bed with Ann Melton. Whether James Melton was aware of his wife's brazen infidelity is not known.

By March 1, 1866, Ann Pauline Foster, a young woman who lived in Watauga County, had visited with her distant cousin Laura Foster in Caldwell County. It is not known exactly why she visited Laura, but she mentioned it in her testimony. They were related only as fourth cousins, but that they knew each other was a fact. At a later date, Laura was reported to have sent a

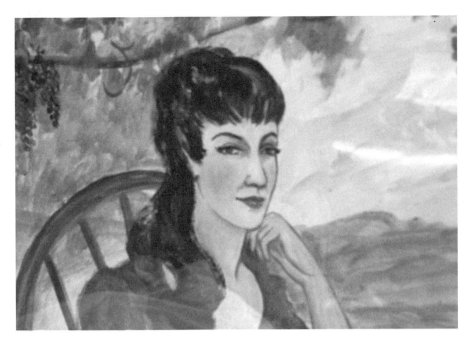

An illustration of Ann Foster Melton, painted by Edith F. Carter. *Courtesy of the Whippoorwill Academy, Tom Dula Museum (WV/TDM), Ferguson, North Carolina*

message to Pauline by a young Negro boy. This happened after Pauline had arrived in Elkville and been hired to work for the summer by Ann and James Melton. She was to be paid twenty-one dollars for the summer and was to help James Melton in his fields. Pauline (or "Perline" in the local dialect) had visited in Elkville by early March, but it is not known exactly when she came. Officially, she was visiting her grandfather, believed to be John "Jack" Dula of Kings Creek in Caldwell County. John Dula was Tom Dula's great-uncle, and Pauline's father was the illegitimate son of John "Jack" Dula with a Foster woman. Pauline's family had lived in King's Creek near John Dula during the Civil War but had moved back to Foscoe in Watauga County, where they owned land, sometime after the end of the Civil War.

During the Tom Dula trial, Pauline admitted that she had come to Elkville to be treated for "the pox," a venereal disease she had contracted while at her home in Watauga County. She came to Wilkes because the only doctor in the neighboring three counties lived there. Perhaps she first visited with her cousin Laura Foster looking for a place to find summer employment. She would need the money to pay for her medical treatments. It was reported

that she encountered the Meltons at the post office, which would have been at Cowel's Store in Elkville, and they offered her a job for the summer. She testified that after she came to live with the Meltons, Tom Dula came to visit there almost every day and that she (Pauline) and James Melton each slept in one of the three separate beds in the house. Most writers have overlooked or ignored the fact that James and Ann Melton had a five-year-old daughter named Jane, who undoubtedly occupied one of the beds, likely sleeping with her mother, Ann.

Pauline testified that Ann did not sleep in the bed with her husband, but she did not state why. Sometimes Pauline shared her bed with Ann, and at such times, Tom Dula sometimes came into their bed as well. When guests visited the Melton home, they often found Pauline sitting on Tom's lap, and sometimes the two disappeared into the barn together. During her testimony, Pauline claimed that she had only done this as a front for Tom and Ann. She said that she did it "on a blind," at Ann's request. Other witnesses suggested that Pauline did not need any encouragement to be with either Tom or other men, and George Washington Anderson testified that she had "been together with" both him and Tom Dula in the woods on at least one occasion. However, Pauline denied having sexual relations with either of them. This, too, will be examined in a later chapter.

EVENTS OF MARCH 1—MAY 24, 1866

About March 1, 1866, Tom Dula started visiting and courting Laura Foster, according to her father's testimony. He surprised them in bed together on more than one occasion. Some sources claim that Tom and Laura got together earlier in January, but no testimony supports that. Tom must have stopped visiting soon after, though, as Wilson Foster, in other testimony, states that Tom hadn't visited for about two months before his visit on Sunday, March 20. At the beginning of April 1866, Tom applied to Dr. George N. Carter to be treated for a venereal disease, likely syphilis in the first stage. He told the doctor that he had contracted the disease from Laura Foster.

Soon afterward, Ann Mellon also started receiving treatments. During the trial, Tom's contraction of syphilis from Laura Foster and his later transmitting it to Ann was listed as one of the stronger motives for the murder of Laura Foster. John Foster West, in his book *Lift Up Your Head, Tom Dooley*, tried to prove that Tom couldn't have contracted the disease from Laura Foster

An illustration of Laura Foster, painted by Edith F. Carter. *Courtesy of WV/TDM.*

Dr. George N. Carter, a Dula relative by marriage and the only physician in the Tri-County Region. *Courtesy of WV/TDM.*

but must have contracted it from Pauline Foster and that he later spread it to both Laura and Ann. If this were true, Tom would have no motive for killing Laura. According to West, the time from when Pauline came to Elkville until Tom looked up Dr. Carter fit the normal incubation time for the first stage of the disease. If one allows one week from the time of Pauline's arrival, until the time she and Tom could have begun a sexual relationship, it might fit. However, if Tom didn't start having sex with Laura until the end of March, it actually could not have been Laura who gave him the disease. There wasn't time enough for the disease to break out between the end of March and Tom's seeking treatment from Dr. Carter in the beginning of April.

Unfortunately, this does not weaken Tom's motive for the killing because he still believed it was Laura who had given him the disease. So whether Tom contracted his disease from Laura, Pauline or some other woman (and there was at least one other), it doesn't matter. What matters is from whom he believed he got it. Ann Melton had also railed against Laura Foster for the same reasons. The source of the pox is further dealt with in a later chapter.

On Sunday, May 13, 1866, Tom visited a riverside neighbor, Rufus Dula Hall. Tom said that he was returning from "preaching," meaning he had just come from church. Tom Dula then told Rufus D. Hall that Laura Foster had given him the pox, and he threatened to "put through" the person who gave him syphilis. Rufus testified that he advised him, "Tom, I would not do that!" One week later, on Sunday, May 20, Tom visited Laura and spoke with her for about an hour, according to her father. Three days later, on Wednesday, May 23, he visited her again. Wilson Foster (Laura's father) was

not at home when Tom arrived, but upon returning, he found them close together in front of the fireplace. One witness (Betty Scott) testified that she saw Tom Dula that same Wednesday on foot about three miles from Wilson Foster's house. Exactly why the judges and the clerk of the court have found this statement significant is not clear. Wilson Foster had already testified that Tom Dula was visiting his daughter Laura, and placing Tom three miles from the victim's home was actually placing him midway between there and his own home. He could have been coming from anywhere at that location.

The next day (Thursday, May 24), Ann Melton told Pauline Foster that she (Ann) had contracted syphilis from Tom and that her husband, James, also had the disease. She said she would fool James into believing that he had given it to her. How she would fool James is not clear, since he would have had to catch the disease from someone else. There was no evidence of any infidelity on James's part. Ann said she would kill Laura Foster because she had infected both her and Tom, and if Pauline told this to anybody, she would kill her, too. It is not clear whether this was a real threat or just a common local expression used to emphasize strong displeasure with someone. Unfortunately, this conversation is only mentioned in Pauline's testimony and could not be confirmed by any other witness.

Later that same day, Tom Dula visited Ann Melton's mother to borrow a mattock. A mattock is a heavy two-bladed tool for breaking up hard soil and cutting through ground roots. However, it is not very efficient at removing the soil by itself. Commonly, one would also need a shovel to remove the soil. He said he would use the mattock to improve the path leading from his house to Lotty Foster's place and, according to one witness, "to make it more safe to walk at night." Tom also stated to Ann Melton's brother, Thomas Foster, that he wanted to "work some devilment out of his self."

About three months later, Laura Foster's body was found on the ridge a few hundred yards from the site where Tom had worked on the path. In court testimony, this was taken as evidence of Tom having used the work on the path as a diversion while he was actually using the mattock for digging Laura's grave and marking the spot on the path so he could find the grave at night. This point was accentuated by testimony from James Isbell, who stated that once the body had been taken out of the grave, he had seen "blade marks" of a mattock on the side of the grave where the body was discovered. One witness testified that she had seen Tom "skelping" (digging) on the path where he said he was widening it. Another witness said that there had been no improvement made to the path, whereas Mary Dula testified that the path had been improved, but she didn't know who had done it.

Lotty Foster, Ann's mother, testified that "a little digging" had been done in two places on the path between her house and the Dula place. Surprisingly, Rufus D. Horton, one of the richer plantation owners from the valley, served as a character witness for Mrs. Dula, testifying that she was known as an honest and truthful person.

Thomas Dula visited Pauline at the Meltons early on the same morning of Thursday, May 24, and asked to borrow a canteen and to get medication (alum) for the sores in his mouth. He stated that he had met Ann on the nearby ridge, and she sent him there to get the medicine. (Alum is one of the medications used in the treatment for the symptoms of lesions and sores.) Pauline stated that he came before breakfast, between 8:00 and 9:00 a.m., or after the morning chores were done.

Thomas Dula next visited his cousin Carson McGuire Dula early on the same day and asked him to fill the borrowed canteen with "moonshine whiskey." Carson Dula delivered a full canteen of whiskey to Ann Melton at about 10:00 a.m. at the Meltons' home. Ann took a drink and then stated that she was going to take the canteen to Tom at her mother's house. She departed in that direction, south along the Reedy Branch pathway. Whether her young five-year-old daughter was with her was not stated.

Ann took the canteen to her mother's house, where she asked "a little girl" (probably one of her younger sisters) to go down to Mary Dula's house and tell Tom about the liquor. She was not to tell him, though, if his sister Eliza was present. In that case, she should pull his sleeve, or step on his foot or something, and tell him that Ann's mother wanted to see him. The little girl went to the Dula cabin, but she didn't find Tom. He arrived at Lotty

A Wilkes County (Reedy Branch) moonshine still in operation, circa 1900. *Courtesy of the Allen family.*

Foster's cabin later in the afternoon. He talked for a while with Ann and got the canteen filled with liquor. Tom and Ann then left the cabin, going in opposite directions toward their respective residences. The time was about 3:00 p.m., but Ann did not return to her house that day.

Washington Anderson, a neighbor of the Meltons, visited the Meltons' house

for about two hours later that day. He reported that James Melton, Jonathan Gilbert and Pauline Foster were there, but Ann Melton was not present. Ann Melton did not return to her residence until early the next morning—an hour or so before dawn. She took off her clothes, and Pauline Foster noticed that her shoes and the bottom of her dress were both wet. Ann told Pauline that she (Ann), Tom Dula and her mother (Lotty) had lain out all night, emptying the canteen of liquor. Later, Pauline found the canteen, still containing some liquid, under a tree exactly where Ann had said they left it. This statement will be returned to later, in the epilogue. Again, Ann's daughter Jane is unaccounted for. Perhaps she was at home with her father and Pauline, or she may have remained with her uncles and aunts at Lotty Foster's cabin. Note that Lotty Foster was not recorded as verifying her presence with Tom and Ann on this evening.

THE DISAPPEARANCE:
FRIDAY, MAY 25, AND SATURDAY, MAY 26, 1866

Thursday evening, Laura's father, Wilson Foster, went to bed while Laura stayed up (neither of her two brothers is mentioned during the trial, so perhaps they had gone to bed also). The next morning, Wilson woke up when Laura rose from her bed about an hour before dawn; he later testified that she went outside for a moment. (In some versions of the story, Wilson heard Laura talking to someone, presumably Tom Dula, while she was outside, but he doesn't mention any conversation in his recorded testimony, just that Laura left the cabin.) He also said he thought she went to the dresser and opened it. He fell asleep again, and when he woke up, Laura's bed was empty. When he went outside, he noticed that his horse had disappeared from the place it was normally tied. They had no barn or stable for the horse.

Exactly when Laura left the house is not known, but about a mile and a half from the family's house, near the home of A.P. Scott, she met Betsy Scott, a neighbor of theirs. Betsy Scott stated in her testimony that Laura was riding bareback and was carrying a bundle of clothes in front of her. Betsy and Laura had a brief conversation, and Betsy asked if Tom Dula had come. Laura told her that Tom had come before daybreak and that she was going to meet him at the "Bates Place." The Bates Place was an old abandoned site of a former blacksmith shop that had been owned by a man named Bates. By 1866, it had become overgrown in brush and trees and

The path leading from the Stoney Fork Road (now Gladys Fork Road) to the Bates Place. *Author's collection.*

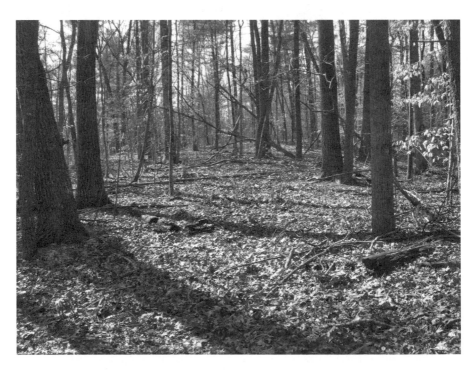

A view of the probable location of the Bates Place (site of Laura Foster's murder). The timber has been clear-cut on the site several times since the 1866 time period. *Author's collection.*

could no longer be identified as a shop site, but people who lived in the local area knew where it had been located.

Earlier, Laura had told another neighbor, Elizabeth "Betty" Scott, that Tom had promised to meet her at the Bates Place, and Laura suggested that they were planning to run away together. There was no recorded testimony that they had planned to marry. Local rumor states that they were running away to be married and that Laura might have been pregnant. However, both Tom and Laura were over age twenty-one; thus, there was no reason to leave the area and run away to be married. Of course, they could have planned to elope locally. Also, no testimony, rumored or otherwise, even suggested that Laura was pregnant, or "enceinte," as stated by the reporter for the *New York Herald* in his article.

When Betsy Scott, whom Laura met on the River Road, asked Laura where Tom was, she said Laura told her that he had taken another route to "flank" one "Manda Barnes." There was no Barnes residence shown on James Isbell's map of the area, so it is not known where this Manda Barnes actually lived. In the 1870 census, no Mandy, Manda or Amanda Barnes is listed on the Wilkes County side of the county border. She could have lived in Caldwell County, moved from the area or been married by then. In other testimony, Tom was said to be "flanking Frank and Manda Barnes place." Pauline Foster had testified that Ann Melton had quarreled with Tom over a Caroline Barnes, who may have been the wife of W.W. Barnes, who lived in Caldwell County. It remains unknown what Tom's movements by the Barnes place, wherever it was, had to do with the events of May 25, 1866. Betsy Scott also testified that she said to Laura, "If she were running away with the likes of Tom Dula, she would have been farther along the path by now." Presumably, this was a comment on the reliability of a person with Tom Dula's reputation in the local neighborhoods.

No one else talked to Laura after her alleged conversation with Betsy Scott (except maybe her killer). In an article in the *Record of Wilkes* dated June 26, 2002, the paper quotes an interview with Amelia Shepherd. She was the granddaughter of Mary Jane (Ballou) Witherspoon, a sister of the trial witness Theodocia Witherspoon. According to Mrs. Shepherd, the two sisters had been in the field near their house along the riverside road and had seen Laura pass by them on her horse that Friday morning, but she didn't report speaking with her at that time. Mrs. Scott's testimony was a point of contention in the first trial. The defense had objected to her testimony as "hearsay" because no other witness could verify the conversations. The Supreme Court appears to have agreed with the defense's objection by

granting Tom a new trial. It also was the only direct evidence on the record that could put Tom at the scene of the murder. Others had testified to seeing him going in that direction, but no one had placed him at the presumed scene of the murder.

Tom must have left Laura's home sometime before her if he actually visited her on that morning. He didn't follow the same riverside road that Laura used but took a more direct, westerly path through the hills. This path was about one mile shorter than the river road, so even if Laura was riding a horse, as was established during the trial, Tom could have reached the Bates Place before Laura. By constructing a time line of his movements from the testimony of witnesses who spoke to or observed him that morning, it seems he could have arrived near the Bates Place by about 10:00 a.m.

If Laura had left shortly after sunrise (the sun rose sometime between 6:00 and 6:30 a.m.) riding a horse, she would have taken about two to three hours to reach the Bates Place. Thus, she could have been there by about 9:00 or 10:00 a.m. Laura would have been waiting for Tom after that time.

On his way, Tom met one Carl Carlton, who had his cabin near the path Tom was traveling. They spoke for about five minutes, and Tom asked him if the path led to (Hezekiah) Kendall's residence. Carlton confirmed that it did, and Tom continued on. About 8:00 a.m., he met Hezekiah Kendall near his home. Kendall asked him if "he'd been after the girl [women]," to which Tom replied, "No, I have quit that!" Kendall noticed that Tom's pants appeared wet from the morning dew. Shortly after breakfast, Tom arrived at James Scott's home. There, he spoke with Mrs. (Celia) Scott, who offered him breakfast. He declined the offer but rested on the steps outside the house for a few minutes. He told Mrs. Scott that he was looking for her brother, George Washington Anderson. A little later, he arrived at Ann Melton's house. Pauline Foster was outside planting corn, and when she came back to the house to milk the cows, she found Tom there, talking quietly with Ann, who was still in bed. Shortly afterward, Tom left the house, going southward in the direction of Lotty Foster's home. Pauline testified that from where she was in the field planting corn, she would have seen Tom if he had come from the direction of the Bates Place, and she had not seen him. Presumably, neither had James Melton, who was also working in the field with her. At least, there was no recorded testimony by James of his seeing Tom Dula at all that morning. The path or road (Stoney Fork Road) leading past the Bates Place was in view from both James's and Francis Melton's properties, and passersby could be seen from their fields.

A present-day view of the Gladys Fork Road (Stoney Fork Road) leading past the Reedy Branch settlements to the Bates Place (at the top of the ridge). This is the route taken by Laura Foster and Tom Dula to reach the Bates Place in 1866. *Author's collection.*

After speaking with Ann Melton, Tom Dula left the James Melton cabin and went down the path to Lotty Foster's house, where he stopped in and asked for some milk. Lotty gave him a half gallon of milk, and he left in the direction of his own home. Lotty Foster stated that "the boys," meaning her sons, had gone out to their work by that time.

Nobody knows what Tom did between getting the milk and noon, when his mother found him at home. Mary Dula had left home shortly after breakfast, and at that time, Tom was not at home. This must have been while he was visiting with either Ann Melton or Lotty Foster. When she got back, just before dinner (lunchtime), he was in the house and was lying on the bed. (In the testimony, a lot of people use the word "dinner" for the midday meal, while the evening meal is called "supper.") Even if Mary didn't see Tom before noon, it was supposed that he was at his house. His sister was at home, and Mary stated in her testimony that Eliza never mentioned Tom being away. For some unknown reason, Tom's sister, Eliza Dula, was not recorded as being questioned during any of the trials, so she didn't confirm or deny Tom's presence or absence at home.

The main point here is that Tom Dula was unaccounted for from about 10:00 a.m. to about midday dinnertime, when his mother, Mary Dula,

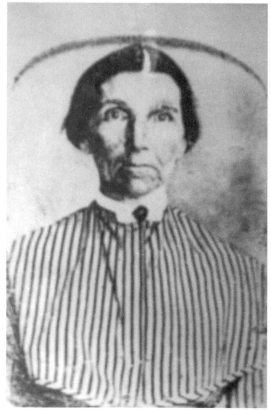

Above: The Reedy Branch stream and path at the site of Tom Dula's home. The Dula cabin stood on a rise just to the right of the small pine tree on the far right in the photo *Author's collection*

Left: Mary Keaton Dula, the mother of Thomas C. Dula and a Reedy Branch resident. *Courtesy of WV/TDM.*

returned home. Tom's mother stated that her grown daughter, Eliza, lived with her, but she (Eliza) was not called to testify about Tom's whereabouts during that time period. One could speculate that Tom went to the Bates Place and killed Laura, hid her body, relocated the horse and then returned to his home by noontime. Another possibility is that he took her some food and told her that he had to go home and pack for their trip and that she was to hide and wait until he could return for her later in the day. He then returned later, executed the murder and placed the body where he could go back, retrieve it and bury it after dark. He could have moved the body, with the horse, closer to the already-dug grave site and then buried it there later. However, there was no hard evidence to support either of these suppositions.

At noon, Tom Dula ate his dinner (lunch) and stayed at home all afternoon. About 3:00 p.m., Mary Dula left the house to tend to her cows. While she was out with the cows, she met two Gilberts, Jesse and Carson. According to Jesse Gilbert's later testimony, she told them that she didn't know where Tom was, but she denied this in her own statement. It was on this occasion that Rufus D. Horton acted as a character witness in her favor. His recorded statement was that "Jesse Gilbert was known for lying and stealing."

Later in the day, while Mary Dula was cooking supper, Tom had gone out to the barn (she assumed) and had stayed there for a while, according to her statement. However, Lotty Foster and her son Thomas testified that they had seen Tom Dula on the path that led to Ann Melton's home; the path also led to the Bates Place. After supper, when it got dark, Tom left his house again. He didn't visit at James Melton's this time, and nobody knows where he went. Later, he returned to his home and went to bed while complaining of chills. His mother testified that she heard him moan several times during the night, and she rose from bed to look in on him. Tom stayed in bed all night and didn't leave the house until after breakfast Saturday morning. The chills Tom was experiencing could have been from the fever he had during his military service or from the second stage of syphilis.

Prior to that Friday, Wilson Foster had been trimming his horse's hooves but hadn't completed the job before Laura left on Friday morning with his horse, so one of the horse's hooves made a distinct mark. He followed the horse's tracks down the road from his cabin, passing A.P. Scott's house, where Laura had met Betsy Scott, and went farther on toward the Bates Place. There he lost the tracks in an old field. He returned to James Scott's house, where he had breakfast, and told them about his missing daughter and horse. From there, he continued to the Melton place. When he arrived, Ann was there alone and still in bed. It is presumed that she was severely

"hung over" from drinking the strong moonshine whiskey Thursday evening and night.

Meanwhile, Wilson Foster left James Melton's cabin after stopping and talking with his niece Ann for about fifteen minutes. He visited several of the other nearby houses asking for his daughter, but no one reported seeing her. Later, about dark, he returned to the Melton cabin, where he stayed

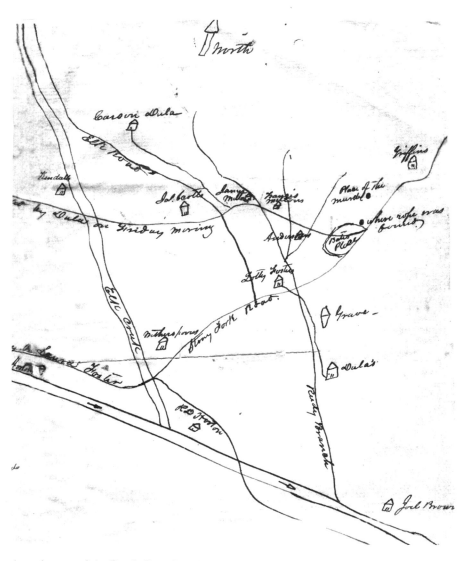

A crude map of the Reedy Branch settlements and locations of the residents' homes. Excerpted from Exhibit A of Colonel James Isbell's Trial Map. *North Carolina Archives and author's collection.*

for two or three hours. A few other people were also present: Ann Melton and her younger brother, Thomas Foster; George Washington Anderson; and a man called Will Holder. Thomas Foster testified that Tom Dula was not there. The party entertained themselves, probably under the influence of a certain amount of liquor, and Thomas Foster burned some of Wilson Foster's whiskers as a practical joke. Since Tom Dula was not there, Wilson Foster thought that Laura and Tom Dula could have run off together with his horse. According to Pauline, Wilson Foster had said on this occasion "that he didn't care what happened to Laura as long as he got his horse back." Pauline Foster allegedly told him that she would get his horse back for a quart of liquor, but later, during trial testimony, she claimed that she had said it "for fun."

Wilson Foster denied his statements about the horse and about Laura. He also denied saying that he would "kill Laura" if he found her. Someone must have accused him of saying so, but who this someone might have been does not show in the records. It should be noted that his horse was his most valuable possession, and he had lost a mule to the Union forces when they passed through the area. He had filed a claim for the value of the mule, but it had been denied. His anger at Laura is understandable in that horse stealing

The Anderson home, located near the Bates Place (see Isbell's map), circa 1900. This house was the home of witnesses George W. and Eliza Anderson in 1866. *Courtesy of WV/TDM.*

was a hanging offense during those times. When Wilson Foster left the party, he went across to the home of James Melton's brother, Francis, who lived close by (Francis lived just across the Reedy Branch from his brother James), and stayed there for the night. The Anderson family also lived close by and in the direction of the Bates Place.

THE EARLY SEARCHES:
MAY 26 TO THE BEGINNING OF JUNE 1866

After breakfast on Saturday morning, Tom Dula again visited the Melton place, according to Pauline Foster's testimony. He came to have his shoes repaired by James Melton, who did cobbler work in addition to his farming, carpentry work and wagon making. At that time, he spoke with Ann for a long time, and when Pauline told him that she thought he had run away with Laura Foster, he replied that he "had no use for Laura Foster." Tom then left but returned in the evening with his fiddle, with which he entertained until almost midnight. Tom spent the night at the Meltons and slept with James Melton. Thomas Foster also spent the night there and sat up with Pauline until about midnight, when they went to bed. He slept in the same bed as Pauline Foster. Presumably, Ann slept in the third bed with her daughter.

That same morning (Saturday), Wilson Foster left Francis Melton's house and returned to his own home at German's Hill in Caldwell County. There he found his horse had returned. The rope it had been tied with looked as if the horse had "gnawed through it." Apparently, the return of the horse with a broken rope did not instigate an immediate search for Laura, and it was probably still assumed that she had run away. Nothing much was said about the initial searches in the surviving records, so it is not known exactly when they were started. The reason searches might have begun is that Tom Dula was still in the community, so no one knew with whom Laura could have left. J.W. Winkler testified that a general search was carried out and that he had searched for seven or eight days. The searches presumably started some days after Laura's disappearance. It is normally assumed that the search was carried out by several people from the Buffalo (Caldwell) community, together with residents from the neighboring Elkville (Wilkes) communities.

It is not known exactly who participated in the searches, but one of the participants was James Isbell. In one of his statements, he described part of the search. Unfortunately, his statements are not recorded correctly

in the chronology of the search events. His statement appears in his testimony right after he mentioned how Laura's body was found, but when one reads the statement, there are indications that this part of the search must have taken place much earlier in the search periods: "During the search, we discovered a large mud hole near Francis Melton's, which we intended to drag, but it being late in the evening, we put it off until the next day. The next day we discovered signs of mud leading off from that direction toward the Yadkin River near the Witherspoons. We had not noticed these signs the day before. We dragged the hole, but found nothing." If the search mentioned in this statement took place after Laura's body was discovered, there would be no reason to drag a pool, and there was no reason to believe that signs of mud leading toward the Yadkin River three months after Laura's disappearance had anything to do with the crime. In any event, nothing about Laura's disappearance was discovered through the early searches for her.

THE MONTHS THAT FOLLOWED

After Laura's disappearance, the area searches for her continued. Even if it was not mentioned during trial, it must be assumed that the searches were most intensive in the days right after the disappearance and then were slowly reduced to Sundays and perhaps "after work hours." Everybody had to take care of their farms and plantations, so they didn't have time for a month of long all-day searches. Some must have continued searching though, and while the searches still took place, other events with bearings on the case were occurring.

That the searches became intensive from time to time during the next month was confirmed at the trial. On Sunday, June 24, J.W. Winkler testified that the neighbors (presumably residents from the Buffalo and Fort Defiance area of Caldwell and possibly from the Reedy Branch settlements and Elkville in Wilkes) were out in force. They formed a search line, like a line of battle—everyone walking in line with a few feet between one another. The search was conducted in the vicinity of the Dula house, but with no success. Later the same day, the search was moved to the Bates Place. Here, a piece of rope was discovered tied around a dogwood tree. Winkler himself saw the rope soon after it was discovered. Wilson Foster testified that he had identified the rope as the one with which his horse had been tied. He was

sure of this because he had made the rope himself. Winkler testified that the branches of the tree had been nipped off.

About one hundred yards from the dogwood tree where the rope was found, the search team found another place with traces of a horse being tied up. Winkler also mentioned a discolored spot on the ground about the size of a man's hand. The earth here had an offensive smell, different from the earth around it. The ground had been covered over with leaves and twigs, and branches of the nearby bushes had been broken and were hanging down. Winkler later testified that he thought the discolored spot was blood and that someone had tried to conceal it. The spot was about fifteen to twenty feet from the tree where the horse was tied the second time. James Isbell, who was also participating in this search, corroborated Winkler's testimony.

James Isbell was present when the rope location was found and also when the second location was found. He expanded on Winkler's explanation by relating that the "horse had dunged twice," indicating that it must have been tied there for some time. It must be assumed that the latter place must have been where the horse was first tied, and it was later moved to the second place, where rope was found. Why the horse was moved is not known, but one can speculate that Laura might have gotten to the Bates Place first and hid herself and the horse. After she was murdered, her killer must have moved the horse to the second location, perhaps in order to find a better hiding place. Another possibility is that the killer used the horse to move the body closer to the prepared grave site and then returned it to the second place it was tied. Why he didn't just release the horse is not known. It was noted in testimony that Tom Dula never participated in any of the searches, even when they were searching near his home. That fact added to the suspicions that Tom Dula was somehow involved in Laura's disappearance.

After Laura's disappearance, Tom visited Ann Melton every day or night, according to Pauline Foster's testimony. On the Sunday when the rope was found, he came in the evening. James Melton was at home, and he told Tom that some of the Hendrickses were starting rumors that Tom must have killed Laura Foster. Unfortunately, it is not specified to which Hendricks James Melton was referring. There were a large number of Hendricks families in the area. In fact, Tom's older sister, Anna E. Dula, was married to a Micajah Hendricks, a local miller, who was a witness at his trial. They are believed to be the couple who received the body of Tom Dula after his hanging. Dula reportedly laughed at James's comments and replied, "They will have to prove it and perhaps take a beating besides." He then left, presumably to confront the Hendrickses about the rumors. The next day (June 25), Tom

THE MURDER OF LAURA FOSTER

reportedly looked up some of the Hendricks families in order to threaten them with a "beating." He then returned to the Melton place but was rather depressed. Ann Melton had made some preparations by making a hole in a wall with a knife. She then pulled a string through the hole, tying it to a nail outside and later connecting the string to her bed inside. She would place the string on her wrist at night. Her objective was for Tom to signal his presence from the outside without disturbing the others inside.

When Tom returned, Pauline offered to prepare a bed for him, but Tom decided to go to his own home. However, he changed his mind and stayed for a short time at the Melton home. Pauline testified that she went to bed with Ann and that she felt Ann crying. After some time, Tom joined the two of them, and both he and Ann were crying. A little later, Tom and Ann were both upset and went out into the yard. Pauline followed them and asked Tom what was the matter. Tom told Ann and Pauline that someone was telling lies about him. He denied having anything to do with Laura's disappearance, but he was afraid that the community was turning against him and he would have to leave the area. Not stated, but likely anticipated, was the threat of a lynch mob. Tom said he would return at Christmastime to get Ann and his mother. Why he thought his mother would leave her property and family to go with them is not known. Tom said goodbye to Ann and Pauline and left. Ann returned to the cabin crying, and when her husband asked her why she was crying, she told him that Tom Dula was leaving.

Tom left Elkville for Watauga County sometime during that night or early the next morning. It is believed that Tom's uncle Jack Keaton accompanied him on the trip. Jack Keaton was Tom's mother's half brother but was near Tom's age himself. Jack's parents (and Tom's grandfather) lived in Watuaga County, and they probably stopped there for a while after leaving Wilkes County.

THE WARRANT FOR ARREST

On Monday, June 28, the justice of the peace from Elkville, Pickins Carter, sent a sworn complaint from Wilson Foster to the sheriff of Wilkes County. In this complaint, he ordered the sheriff to arrest Thomas Dula, Ann Pauline Melton, Ann Pauline Dula and Granville Dula, all of Wilkes County. The reasons for issuing the arrest warrant, the justice of the peace stated, were "that upon the oath of Wilson Foster, his daughter Laura Foster

had mysteriously disappeared from her home under circumstances as to induce him to believe that she had been murdered or otherwise foully dealt with by certain persons under suspicion." Wilson Foster had stated earlier, after Laura's disappearance, that he thought that she had simply run away. Something (or someone, possibly the Hendrickses) must have made him change his mind, but it was never revealed what that might have been.

The persons under suspicion were, of course, the four people Carter named in the arrest warrant. Three of the named persons—Ann Melton, Ann Pauline Dula (Pauline Foster) and Granville Dula—were taken into custody and brought to a hearing before Pickins Carter at Cowel's Store. Some confusion occurred about the persons named in the arresting documents. Ann Pauline Dula was named in the warrant, but it was actually Ann Pauline Foster whom Wilson Foster wanted arrested. Pauline Foster is believed to be the daughter of Levi Leander Foster, who was the illegitimate son of John "Jack" Dula, the grandfather Pauline had visited. When Levi was living near his father in the Kings Creek settlements, he and his family were known as Dulas. Wilson Foster, who knew Ann Pauline Foster as Ann Pauline Dula, named her as a Dula in the complaint. Why Granville Dula, Tom's first cousin, was also named is not known. Possibly he had been a suitor of Laura's, but that is just speculation. Another possibility is that Pickens Carter mistook Bennett Dula's children, Ann Pauline and Granville Dula, Tom Dula's first cousins, for the persons Wilson Foster had named. One should keep in mind that most of the participants were illiterate, and could not read or otherwise verify the written complaint. The Wilkes deputies, Jack Adkins and Ben Ferguson, arrested the three persons named in the complaint and brought them before the justice of the peace.

On June 29, a hearing was held at Cowel's Store in Elkville before Justice of the Peace Pickens Carter. The defendants Ann Melton, Granville Dula and Ann Pauline Foster (Dula) pleaded not guilty to the charges alleged against them. They each had alibis for the time when Laura Foster was presumed to have disappeared and therefore were released as not guilty.

It is reasonable to assume that the search for Tom Dula was started shortly after the hearing ended. Tom had not been found anywhere in Wilkes; thus, he was not arrested and was now presumed a fugitive from justice. Pickens Carter issued an order to find and arrest Tom Dula. It was after this hearing that Pauline Foster (Dula) carelessly said to Tom's friend George Washington Anderson, "I would swear a lie for Tom Dooley anytime, wouldn't you, George?"

The deputy, Jack Adkins, overheard her comment and took note to place her under further suspicion of involvement in Laura's disappearance.

In the meantime, Tom had walked up the trail and wagon road that led from Elkville, following Elk Creek and then met up with the old Buffalo trail into Watauga County. He undoubtedly stopped for a short time at his maternal grandfather's home in the Watauga District of Watauga County. It is presumed here that he was accompanied by his (half) uncle Jack Keaton, the son of Tom's grandfather Clifton Keaton and his second wife, the widow Susannah (Mabry) Keaton. Some reports have stated that Jack Keaton was arrested with Tom in Tennessee and was charged with helping him in an escape attempt. However, that was not discussed in any of the transcripts. There is a record of Jack Keaton's arrest, but he was later released because of an alibi. No details of any charges are known.

Tom Dula must have walked from his grandfather's home, through northwestern Watauga County, crossing the Rich Mountain and following the north fork of Cove Creek to Zionville and into Tennessee. That was a distance of about fifteen miles. He arrived at Colonel James W.M. Grayson's farm, near the place known as Trade, Tennessee, around July 4. He identified himself as "Tom Hall" and stated that he needed work to buy himself a new pair of shoes or boots. His shoes had disintegrated on his walk into Tennessee. Tom was later

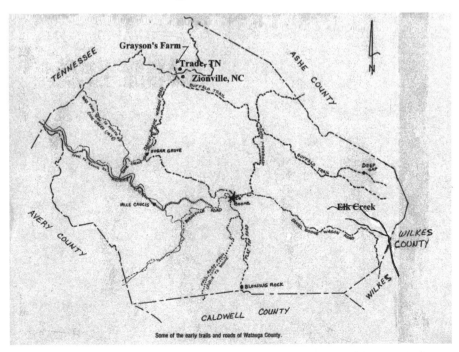

The old buffalo trails and roads of Watauga County that Pauline Foster and Tom Dula would have used in 1866. *Courtesy of the Watauga Heritage Book and author's collection.*

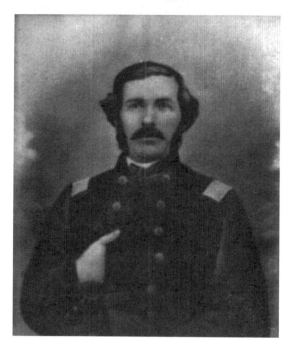

A portrait of Lieutenant Colonel James W.M. Grayson, who lived in Trade, Tennessee, and employed Tom Dula as Tom Hall. *Courtesy of WV/TDM.*

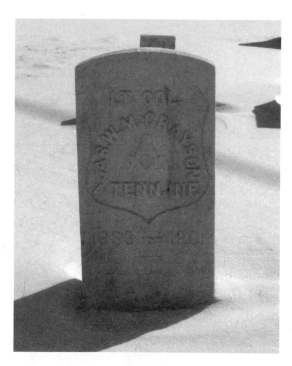

The grave marker of Colonel J.W.M. Grayson in the Zionville, North Carolina First Baptist Church Cemetery. *Author's collection.*

quoted as saying that he used his uncle's name, Tom Hall, as a joke. He worked for four days and then left early the next morning on foot, wearing a pair of new boots. Late that afternoon, a posse headed by the two deputies from Wilkes County, John Adkins and Ben Ferguson, showed up at Grayson's farm. They had attempted to contact the local sheriff at Mountain City, but he was away. They told Colonel Grayson that Tom Hall was actually Thomas Dula (Tom Dooley), a fugitive wanted for a sordid murder on the east side of the Blue Ridge.

Colonel Grayson invited them to spend the night, and the next morning, July 11, 1866, he agreed to help find Dula. He buckled on the seven-shot rim-fire Deermore .32-caliber revolver he had carried through the Civil War and led the deputies in the direction Dula had gone. They overtook the former Confederate at Pandora, nine miles west

of Mountain City. He was soaking his feet in Doe Creek, seeking relief from the blisters the new boots had made. Grayson dismounted, picked up a rock and told Dula he was under arrest. No doubt the pistol Grayson was carrying influenced Dula to surrender.

Grayson put Dula on his horse behind him and returned to his home near Trade, where they spent the night. Dula was locked in a corncrib, and W.F. Grayson, who was a young boy at the time, guarded Dula during the night. The next morning, Colonel Grayson put Dula on the horse behind him. He bound his hands and tied his feet underneath the belly of the horse and headed to Wilkes County to deliver the prisoner to jail. If it hadn't been for Grayson, Tom Dula might well have stayed in Tennessee as the old ballad states. But it was not to be.

Grayson did not return to Wilkes County to testify against Dula in the trial of 1866 or in the fall term of 1867. During the trial of 1868, Grayson was in Nashville as a member of the state legislature. The summons on record to Grayson did serve a good purpose a few years later. It provided the researchers of history and folk music the clue to the identity of Grayson when "The Ballad of Tom Dooley" became popular. The interest in the identity of Grayson and his connection to Tom Dula was only natural since his name was the only name other than Tom's in the ballad.

A Grayson family tradition is that Colonel J.W.M. Grayson finally had to use his pistol to keep the group from North Carolina from lynching Dula on the spot when he was found and captured in Tennessee. Grayson and Dula were both veterans of the horrible Civil War, although on different sides, and Grayson was determined that he wouldn't hang in Tennessee. He was determined to return Dula to North Carolina personally to see that he got a fair trial by jury. Perhaps Grayson felt that there had been too many illegal hangings there during the Civil War.

Colonel Grayson's nephew, Gilliam Banmon (G.B.) Grayson, from Laurel Bloomery, Tennessee, made one of the first recordings of "The Ballad of Tom Dooley," and Henry Whitter traveled to Memphis and recorded the song for Victor Records on October 1, 1929.

On Wednesday, July 11, Tom was incarcerated in what is now known as "The Old Wilkes Jail." There were reports that during the trip, Tom had attempted to escape but was unsuccessful. There were also reports or rumors that the posse was inclined to hang Tom when he was captured, but Colonel Grayson had prevented them from hanging him. No documents are available to verify that. Some writers have claimed that Tom was illegally extradited from Tennessee and thus should not have

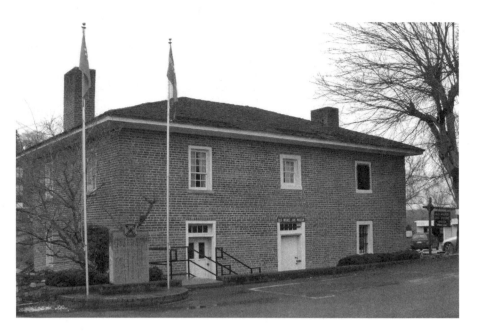

The Old Wilkes Jail in Wilkesboro, North Carolina, where Tom Dula and Ann Melton were held. It is now a museum displaying artifacts from the time of Tom Dula's life. *Courtesy of the Wilkes Heritage Museum, Wilkesboro, North Carolina.*

been arrested. However, at that time, North Carolina was not a state but a district under military jurisdiction. Tom was apprehended under a local policy of "hot pursuit," which allows for crossing boundaries in the pursuit of a fugitive. Furthermore, Lieutenant Colonel Grayson, as a member of the Tennessee legislature and the Union army, could arrest and possibly extradite a fugitive being pursued by legal authorities.

After Tom's arrest and incarceration, about July 16, Pauline Foster became concerned about the community's rumored suspicions of her involvement in Laura's disappearance, and she decided to return to her home in Watauga County. She had told Ann about this in a conversation overheard by Colonel Taylor C. Land, and Ann was not happy about it because she didn't want to do the household chores and the milking of the cows by herself. Ann followed Pauline part of the way, trying to talk her into staying, but to no avail. Some of the testimony implied that her brother, who had come to visit her, accompanied Pauline on the return trip back to Watauga. However, that detail is not clear from the testimony. During her stay in Watauga County, Pauline made a trip into Tennessee, but she did not state why. Pauline's home in Watauga was only about ten miles from the Tennessee line.

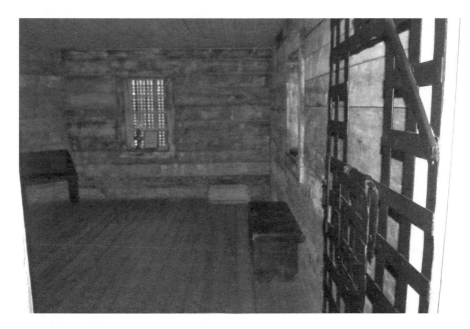

Tom Dula's jail cell in the Old Wilkes Jail in Wilkesboro, North Carolina. *Courtesy of the Wilkes Heritage Museum, Wilkesboro, North Carolina.*

About two weeks later, Ann and her younger brother, Samuel Foster, went up to Watauga County to see Pauline and to try and convince her to return. Ann told her that her absence was making them all look guilty and that the authorities might have plans of coming to arrest her if she didn't return to Wilkes. This incident was part of Pauline's own testimony, but it seems unlikely that a threat of being arrested was what caused Pauline to return to Wilkes. More likely, she needed the money that the Meltons owed her for the time she worked for them. In some later versions of the story, Samuel Foster is said to be Pauline's brother, but it is clear from the census records that he was Ann's younger brother. Pauline eventually agreed to accompany Ann and Samuel back to Wilkes and to resume her work for the Meltons. Pauline, of course, was well aware of Ann's and Tom Dula's possible involvement in Laura's disappearance. Also, with Tom Dula being held in jail, Pauline was now fearful that her knowledge might lead to her own arrest. Pauline later testified in the loose notes that Ann had said that "she had done what she said" in getting rid of Laura Foster. Exactly what that meant and how it was done was not specified in her undated testimony. According to Pauline, Ann had boasted that she could make (Tom) Dula do anything and that she always kept everybody under her control.

A BREAK IN THE CASE

Around August 1, while Tom was still being held in jail, Ann told Pauline that the search for Laura had almost ceased, but she was concerned that if Laura's grave were ever found, Tom might be hanged. About three weeks after Pauline had returned to Wilkes, Ann came to Pauline crying and said to her, "Poor Dula. I wonder if he will be hung. Are you a friend of Dula? I am. Are you a friend of mine? I want to show you Laura Foster's grave. They have pretty well quit hunting for it. I want to see if it looks suspicious." At this point, Pauline knew for certain that Laura had been killed and was buried somewhere in the area. She also knew that Tom and Ann were somehow responsible for her death.

The authorities knew that they could not hold Tom indefinitely without some evidence that a murder had actually been committed. In the meantime, Ann had confided to Pauline that she knew the location of Laura's grave, and she then asked Pauline to accompany her to the grave to see if it had been disturbed. She said that if it looked suspicious, she would dig up the body and bury it elsewhere. Pauline reluctantly accompanied Ann as they walked down by Lotty Foster's house, crossed the Reedy Branch and went up the ridge to a certain log. Near the log, the ground had been disturbed, possibly by hogs or where the dugout soil from Laura's grave had been scattered. Ann covered the exposed ground with leaves that she picked up and carried in her apron. Pauline became more frightened and refused to go any farther up the ridge, so Ann continued on alone. The ridge where the grave was is believed to be on the property then owned by the Dula family. The grave must have been well concealed because Ann returned without the body. Both women then returned to the Melton home, with Ann chastising Pauline all the way back for her cowardice. Perhaps at this point, Pauline realized that she had become deeply involved in a crime and that Ann and Tom Dula were the likely perpetrators.

One evening about a week later, Bennett Ferguson and John Atkins, the deputies who had arrested Tom Dula, showed up at the Meltons to question Pauline about her knowledge of Laura's disappearance. The deputies suspected her of involvement because of her flight to Watauga County after Tom's arrest, her trip into Tennessee and the careless statements she had made after her hearing at Cowel's Store. When they arrived, it was obvious that she had been drinking heavily and was inebriated. They told her that they were inclined to accuse her (Pauline) of being involved in the murder. Ben Ferguson said to her that he (meaning Tom Dula) had killed Laura

Foster, to which Pauline drunkenly blurted out "Yes, and Dula killed her, and ran away to Tennessee." Pauline then said, "Yes, Dula killed her, and he ran off to Watauga County. Come out, Tom Dula, and let us kill some more! Let us kill Ben Ferguson!" The deputies, seeing that she was seriously inebriated, were reluctant to take her comments seriously. They then left but promised to investigate Pauline again at a later time.

Later, she stated in court that what she had said was a joke. Pauline had probably said similar things to James Melton; in her statements in court, she claimed that James Melton had cautioned her "not to joke about such things." Someone must have taken her comments seriously, though, because in court, she denied admitting to James Melton that she had anything to do with Laura Foster's disappearance. It should be noted here that no body had been found, and there was no real or forensic evidence that a murder had actually been committed. However, Ann was now beginning to see that having confided in Pauline about her involvement, and about the site of the grave, might not have been a wise decision.

After her statements to the deputies, Pauline had quarreled with Ann Melton. Ann accused her of being "a drunken fool and that she had said enough to Ferguson and Atkins to hang [her], and Tom Dula." Pauline again excused herself of the comments by saying that they were meant as a joke. Pauline admitted to making the statements, but she claimed, "I had not done the crime!" The next day, Ann and Pauline quarreled once again, this time because Ann wanted Pauline to milk the cows as well as make their breakfast. After the quarrel, Pauline Foster visited a nearby neighbor, Mrs. James (Celia Anderson) Scott. It's not clear how well the two knew each other, but they were acquainted somehow and had been for some time. Pauline stated that earlier, Mrs. Scott had sent a Negro boy with a message from Laura Foster to Pauline. One would assume that this was sometime before Laura disappeared. Soon after Pauline arrived at Mrs. Scott's, Ann also came to the Scott residence carrying a club. She told Pauline to go home and pushed her out of the door.

Outside, Ann pushed Pauline to the ground and tried to choke her, and then the two of them got into a fight. According to Mrs. Scott's testimony, Ann said to Pauline, "You have said enough to Jack Atkins and Ben Ferguson to hang you and Tom Dula if it was ever looked into." (There were two versions of this comment, but this one seems clear.) To this, Pauline replied, "You know you are as deep into it as I am." Then she admitted to saying the comments to the deputies but once again stressed that what was said was a joke. Ann and Pauline then left, going toward the Meltons, but soon

The James Scott family, neighbors of James Melton and prosecution witnesses at Tom Dula's trials. Sallie Scott, James Pinkney Scott, James Scott Sr. and Celia Scott are the adults. *Courtesy of Brian James Call.*

afterward Ann returned to Mrs. Scott's. She told Mrs. Scott not to tell anyone anything about what the two women had said to each other during their quarrel. Ann Melton had told Pauline that she had wanted to "kill her" ever since she made her confession to the deputies. Later, Ann returned to Mrs. Scott's home once again, but Pauline admitted that she didn't overhear what Ann said to her.

Mrs. James (Celia Anderson) Scott also testified about the fight, and for the most part she confirmed Pauline's testimony but with a few differences. According to Mrs. Scott, Pauline had arrived, and Ann Melton followed a few minutes later. Ann ordered Pauline to go home, pushed her out of the chair she was sitting in and hit her with the club. She threw Pauline to the floor and tried to choke her. She abused her verbally and kept ordering her to go home. Ann said that Pauline had told Ben Ferguson enough to hang herself and that she had said that she (Pauline) and Tom Dula had killed Laura Foster and hid the body. She claimed that Pauline also said, "Come out, Tom Dula, and let us kill some more." To Bennett's accusation, Pauline had replied, "I do say now, come out Tom Dula and let us kill Ben

Ferguson." According to Mrs. Scott, Pauline responded to the accusations from Ann with: "It is the truth, and you are as deep in the mud as I am in the mire." At this time, Ann accused Pauline of being a liar. Then the two women accused each other of having "a bad disease." After they left once, they returned, and Ann warned her (Mrs. Scott) about ever telling anybody what was said on that occasion.

According to Mrs. Scott, Ann said that she wanted Mrs. Scott "to make it her dying secret, that she had started out that morning to take revenge and had commenced with her best friend." The transcription of this part of the records is unclear as to what day she is referring. The transcription that seems the most logical is that Ann had "colluded with" or "commenced with" her best friend (Tom Dula) to get their revenge. This wording is consistent with the known facts in the case. Ann could have been referring to the day before Laura's disappearance, when the facts suggest that Tom, possibly in the company of Ann, dug the grave where Laura's body was eventually found. Both were missing from their homes that evening and all night and likely stayed out together until Tom left for Wilson Foster's early the next morning and Ann returned to her own home.

Later, Ann returned once more to Mrs. Scott's, this time alone, and once again threatened Mrs. Scott to "follow her to Hell" if she ever told what she had overheard. Mrs. Scott testified that Ann said that if it were ever told, she would know where it came from, since only four persons knew about it. Mrs. Scott was one, Ann and Pauline were two more and Tom Dula was, undoubtedly, the last (fourth) person. Nothing definite in any of the records is said about a fourth person being present on this occasion. It could have been James Scott, but then why would Ann only threaten Mrs. Scott? There was no mention of his being present at this occasion, and no testimony by him was recorded.

THE DISCOVERY OF THE GRAVE

Two or three weeks after her remarks to the deputies on August 28 or 29, Pauline Foster was taken into custody for questioning and held in the Old Wilkes Jail, next to Tom Dula. After her arrest, Pauline Foster was questioned intensely, and she finally told the authorities about her visit to the vicinity of Laura's grave with Ann Melton. Because of this, she was removed from jail, and a search party went with her to the place where she had stopped and

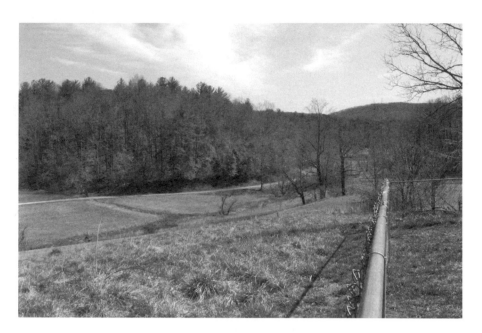

A view of Laura Foster Ridge, where Laura Foster's body was buried. The grave was on the spur of this ridge some two hundred yards above the trail to the Dula's cabin. The trail and Reedy Branch are in the foreground. *Author's collection.*

Ann had continued alone to the site of the grave. This happened about September 1 or 2, 1866. The time is testified to by James Isbell, who must have been present when Pauline was taken from the jail. He continued in his testimony, "We went with her to the ridge and came to the log, and saw where dirt had been removed. This was the spot, where she [Pauline] stated that she stopped following Ann Melton."

Pauline could not direct them from that point on, so a widespread search was begun. How this took place is not clear because it is not described in any of the official records. From James Isbell's testimony, it is supposed that the people present were paired off and then conducted the search in teams of two, sweeping through the ridge area. James Isbell was paired off with his seventy-four-year-old father-in-law, David Horton. David Horton was riding his horse, and from the description in his testimony, it is presumed that James Isbell was on foot. After about thirty minutes, the two of them found a suspicious area about seventy-five yards from the log that Pauline had led them to. Isbell and his father-in-law were apparently alone when David Horton's horse snorted as if it smelled something unusual. Isbell testified that the earth appeared to have been carried away and the surface (sod) replaced.

A view of a wooded laurel thicket of the type where Laura Foster's murdered body was found. This is not the actual burial site, which has been lost to history. *Author's collection.*

The two men cut rods from the local underbrush and began probing the ground in that area. They hadn't taken note of this location until the horse snorted. Isbell continued in his testimony, "We then searched narrowly around the spot and by probing the ground discovered the grave. After taking out the earth, and after the body was removed, I saw the prints of what appeared to have been a mattock in the hard side of the grave." Isbell described the body, its attire and so on. Whether the probing was done by Isbell and Horton only or they called for the rest of the search party at that time is not known today, but at some point they must have called the others to that spot. How many or who was involved is not known. Some sources mention the number was about seventy-four, but that seems to be a very large number just to search a rather limited wooded area.

In the meantime, after the body was initially uncovered, Dr. George N. Carter was called. He testified that he had examined the body "at the

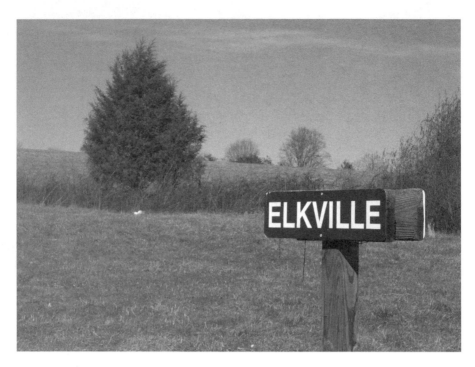

The modern-day location of the site of Cowel's Store and Militia Grounds at the intersection of Elk Creek Road and Highway 268 in Elkville. *Author's collection.*

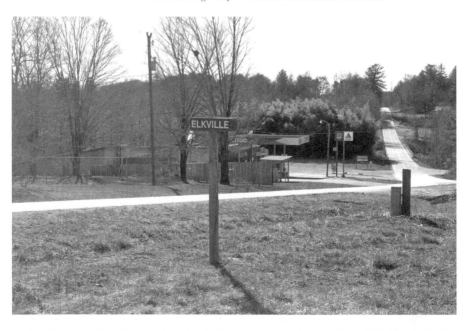

A view from the Cowel's Store location looking toward the intersection of Elk Creek Road and Route 268 at Elkville. *Author's collection.*

spot where it was found." The doctor testified that he had found a cut through the body's clothing and into her body between the third and fourth ribs. He couldn't determine if the wound had been fatal. He said, "If the knife had gone straight in, it would have missed the heart, but if the point of the knife had been pointed slightly down, it could have hit the heart." The body was too decomposed for him to ascertain whether the knife had hit the heart or not. Dr. Carter continued to describe the grave: "The body was lying on its right side, face up. The hole in which it lay was two and a half feet deep, very narrow, and not long enough for the body. The legs were drawn up." Contrary to some reports and popular belief, Laura's legs had not been broken; they were merely drawn up in a somewhat fetal position.

When the doctor completed his on-site examination, the body was taken to Cowel's Store in Elkville. This place was the local gathering spot. It was here that the justice of the peace held his hearings, and it was here that other public affairs were carried out, including the local militia musters.

Pauline Foster identified the body, and she probably did so before it was taken to Cowel's Store as she was only seventy-five yards from the grave when it was discovered. Of course, she already knew it was Laura's grave site. She testified, "I saw the dead body. I thought it was the body of Laura Foster. I recognized her teeth and dress. Her teeth were large, and there was a large open space between them. I had seen the dress before it was made up. It was woven with a single slay."

Wilson Foster, Laura's father, testified that he had identified the body. Apparently, he was not a member of the search party and did not see the body at the grave. "I later saw the corpse of Laura—I knew it by the teeth and by the shape of the face, which looked natural. I recognized her clothes. She had on two dresses—one store clothes, the other house made. I knew her shoes. They had a hole in them, which I remembered. James Melton made them. I recognized her fine-tooth comb. Before leaving home, she had boils about her shoulder." This was another indication that Ann, Pauline and Laura all knew one another well before the murder. If James Melton had made Laura Foster's shoes, she must have visited at the Meltons' home. Laura Foster was Pauline's fourth cousin as well as Ann's first cousin. Pauline may or may not have known Laura well, but she certainly knew her. Wilson Foster was Ann's uncle, her mother's brother, so they undoubtedly were occasional visitors with the Meltons.

J.W. Winkler was never at the grave, according to his own testimony, so he must have seen the body at Cowel's Store. He testified that he was

John Walter Winkler, search party leader and owner of land near German's Hill, where Laura Foster was buried. *Author's collection.*

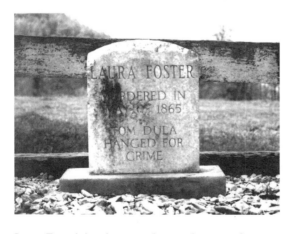

Laura Foster's headstone and grave site across from German's Hill and beside the Yadkin River. The fenced site is across Highway 268 in Caldwell County, near the Wilkes County line. *Author's collection.*

one of the people who identified the body: "I knew Laura Foster. I saw the dead body. I thought from her cheekbones and from her teeth and from the dress, that it was her body. It had on a homespun dress, that I thought I knew." J.W. Winkler was Wilson Foster's friend and neighbor. He would have known Laura well.

Today, identification of the body would have been easy using DNA or dental records, but by the standards of the time, these identifications were probably the best you could get of a body that had been buried for more than three months. Unfortunately, Pauline Foster confused the time line a bit when she testified, "I hadn't seen Laura Foster since the first of March. It was nearly three months between that time and the discovery of the body." Actually, six months had passed from March 1 to the discovery of the body in early September, but it must be assumed that the dates agreed upon by everyone involved were correct; either Pauline's concept of time was wrong or her testimony was wrongly reproduced

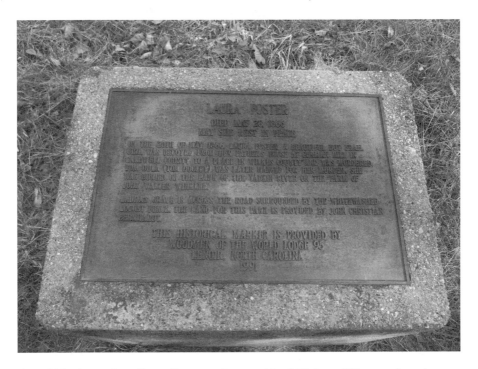

A roadside plaque about Laura Foster on the west side of Highway 268 across from the Laura Foster grave site in Caldwell County. The grave site is on private property and is not accessible to the public. *Author's collection.*

A view of Laura Foster's grave off Route 268 at German's Hill in Caldwell County. *Author's collection.*

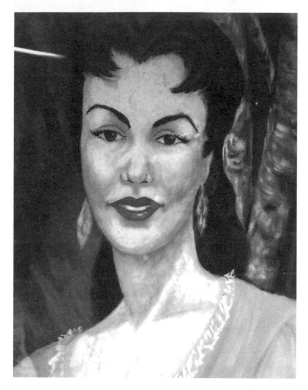

Edith F. Carter's portrait of Ann Melton. *Courtesy of WV/TDM.*

The cell in the Old Wilkes Jail where Ann Melton was held before and after the Tom Dula trials. *Courtesy of the Wilkes Heritage Museum, Wilkesboro, North Carolina.*

in the official records. Another possibility is that Pauline was attempting to distance herself from Laura's disappearance.

After the inquest and autopsy, Laura Foster's body was taken to her home area of German's Hill in Caldwell County and reburied on land that belonged to J.W. Winkler, her neighbor. It is actually across a field near present-day North Carolina Route 268, where her grave site and tombstone can still be seen. Unfortunately, the date of the murder on the headstone is incorrect— it states that she was murdered in May 1865. At that time, Tom Dula was still in the POW camp in Maryland. The murder is believed to have taken place sometime on Friday, May 25, 1866.

After the discovery and exhumation of Laura Foster's body, Pauline Foster was released from custody. Ann Melton was arrested in her place and put into a cell in the Old Wilkes Jail next to Tom Dula. Now with

firm evidence of a murder, the authorities began the legal procedures of indictment and preparation for trial.

THE TRIALS OF TOM DULA

THE INDICTMENT AND FIRST TRIALS

The trial of Tom Dula took almost eighteen months even if less than a week's time was actually spent in court. The Superior Court of Wilkes met only twice a year, once in the spring and again in the fall. The reason it was called the "Superior Court" was that it was superior to the minor courts such as the justice of the peace courts where the warrants for the arrest of Tom Dula and the others were issued. Justice of the Peace Pickens Carter had issued this warrant. The state Supreme Court, in turn, oversaw these Superior Courts. The Superior Court judges were often not local residents but circuit rider judges who moved from district to district according to a schedule.

THE POLITICS OF THE MURDER CASE

The first hearing in the case *The State vs. Thomas Dula* was a grand jury hearing on the first day of the fall term of the Superior Court of Wilkes County on Monday, October 1, 1866. Eighteen men ("good and law abiding") from Wilkes County were selected, and Judge Ralph P. Buxton presided. Judge Buxton was the leader of the Republican Party in the Cape Fear region of North Carolina. During the trial of Tom Dula, Ralph Buxton served as

judge, appointed by the (militarily appointed) Republican governor William Woods Holden. Buxton was later (1888) elected to the position of Supreme Court judge. Holden had lost the 1864 election to Tom Dula's leading defense lawyer, Zebulon B. Vance. Vance won a landslide victory, with Holden winning only three counties during the election. One of the counties he won was Wilkes. When Vance was arrested after the Civil War and removed from office, Holden was appointed by the military as North Carolina's governor. Holden had campaigned on the issue of North Carolina leaving the war. Note that Wilkes County had supported his position. Holden was later removed from office in 1871 after being convicted in a case in which he was charged with allowing the severe treatment of North Carolina citizens by the state militia. One of Holden's defenders at the impeachment trial was Nathaniel Boyden, assistant prosecutor during the Dula trial.

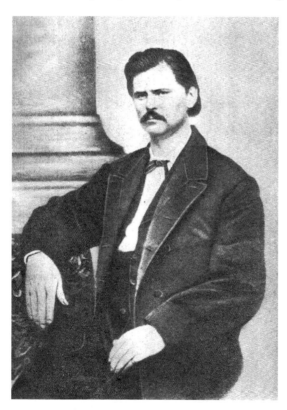

Zebulon Baird Vance, former North Carolina governor and lead defense attorney for Tom Dula and Ann Melton during each of their trials. *Courtesy of the Caldwell County Library and author's collection.*

The reason the political issues are discussed here is that some think the reason Zebulon B. Vance became Tom's defense attorney pro bono was that all members of the prosecution's team were Republicans. Vance was a Democrat and not exactly a fan of Governor Holden, whom he had defeated for office in 1864. Furthermore, the murder of Laura Foster and the impending trial was attracting attention in the national press. Vance was temporarily out of politics but perhaps was planning to (and later did) run for office again whenever his suspension was lifted. As wartime governor, he had been arrested and held in prison in Washington, D.C., for a short time; he

THE TRIALS OF TOM DULA

was then released but barred from holding elective office. By defending Tom Dula and being in the public eye, he could keep his image alive for his future political plans. He may have harbored some resentment toward the Republicans because of his incarceration by their administration.

Vance did not defend Tom Dula because he was a member of Vance's former regiment, as was widely rumored. Tom was in the Forty-second Infantry Regiment, whereas Vance had commanded the Twenty-sixth Infantry Regiment before he ran for governor, and he did not know Tom Dula. Vance may have had additional motivation to defend Tom Dula and Ann Melton because Ann's husband, James, was the former standard-bearer for Vance's infantry regiment. He would have known Colonel Vance at that time, but how well he knew him is not known. Melton relatives have claimed that James's connection with Vance contributed to his reasons for taking the case. Other stories have Major David Horton, a relative of Tom's, asking Vance to defend Tom. Again, there is no recorded evidence to support these tales. Another story is that Governor Holden ordered Vance to take the case pro bono. While it is possible that Holden could have assigned Vance to take the case, he could not order him to take the case pro bono. The state would have had to pay Vance for his services if Holden ordered him to take the case. No known documents support any of these stories. The possible involvement of one of the Dula's Horton cousins is discussed later.

Holden may have appointed Vance, his political rival, in order to reduce his popularity in the state, particularly if he defended a man most believed to be guilty. Again, the true reasons Vance was appointed remain unknown. Tom Dula himself railed against Governor Holden during his last statement before his hanging.

THE GRAND JURY FINDINGS

Of the one hundred or so witnesses called, only about twenty, all from the vicinity of Elkville, were heard by the grand jury. The list of witnesses mentions people who later testified again during the first trial. Most of them are easily identified, but some are not, primarily because their statements during the trials no longer exist. The ones who are known are Dr. George N. Carter, James G. Melton, Wilson Foster, Pauline Foster, Lotty Foster, Celia Scott, Betsy Scott, Betty Scott and Washington Anderson. All of these are listed in the handwritten court documents. The other witnesses

whose testimonies during the trials are in records (at least partially) are Carl Carlton and Hezekiah Kendall (there listed as Kindall), two of the people Tom met on the Friday morning of the murder. Others mentioned were Thomas Foster, one of Ann Melton's younger brothers; Martha Gilbert, who testified about Tom digging at the path on the Thursday before; and George Washington Anderson, Tom's friend from the Forty-second Infantry Regiment. The remaining witnesses, whose testimonies are not in the official records available today, were John Atkins and Bennett Ferguson, the two deputies who arrested Tom and interrogated Pauline about Tom's having killed Laura Foster.

A very small part of John "Jack" Atkins's testimony still exists. The record states only that he went into Tennessee after Tom, about one month after Laura's disappearance. James Foster was one of the two younger brothers of Laura Foster, and Carson McGuire Dula was Tom's cousin and the man who got the liquor for Tom Dula on the Thursday before the day of the murder. None of their detailed testimonies exist today. Nor do the details of testimony by (Theodocia) Docia Witherspoon, Drewory Atkins or C. (Catlett) C. Jones appear in the written records. Docia Witherspoon lived near the place where the Stoney Fork Road left the Riverside Road and led northeast toward the Bates Place. According to the *Recorder of Wilkes*, she had seen Laura on the morning of her disappearance, so it is assumed that this is what she testified about. Drewory Atkins was probably a relative of deputy John Atkins but of what he might have testified is unknown. The same is true for C.C. Jones. He was one of the wealthy farmers from the valley and was related to the Happy Valley Dulas, but it is not known why he was a witness.

The final witness is listed as Thomas M. Isbell, but the name cannot be correct. The first Thomas Isbell, James Isbell's grandfather, died in 1819, and his son Thomas M. Isbell, James Isbell's father, died around 1860. There may, of course, have been another Thomas M. Isbell, but more likely the name listed is incorrect. It is known that the Isbell who actually testified was likely James M. Isbell. If Thomas Isbell is the correct name, the man was not heard at all during the grand jury hearing, and no Thomas M. Isbell appears later in the second trial witness list or in any later trial records.

The witnesses' testimony caused the grand jury to find that there was probable cause to try Tom Dula for the murder of Laura Foster and to try Ann Melton for "urging and inciting him to murder." The Bill of Indictment is written in the legal language of the period:

The Jurors for the State upon their oath presented that Thomas Dula, late of the County of Wilkes, not having the fear of God before his eyes, but being moved and seduced by the instigation of the Devil, on the 18ᵗʰ day of June 1866, with force and arms in the County aforesaid in and upon one Laura Foster in the peace of God and the State then and there being feloniously, willfully and of malice aforethought did make an assault, the said Thomas Dula with a certain knife of the value of five cents which he the said Thomas Dula in his right hand then and there had and hold the said Laura Foster in and upon the breast of her the said Laura Foster then and there feloniously willfully and of his malice aforethought did strike, thrust and stab, giving to the said Laura Foster, then and there with the knife aforesaid in and upon her breast of her the aforesaid Laura Foster one mortal wound of the breadth of one inch and the depth of six inches of which the said mortal wound the said Laura Foster, then and there instantly died and so the Jurors aforesaid upon their oath aforesaid, do say the said Thomas Dula, the said Laura Foster in manner and form aforesaid feloniously, willfully, and of his malice aforethought did kill and murder against the peace and dignity of the state.

A strange inclusion in this Bill of Indictment is the incorrect date of the murder. The grand jury states that the murder was committed on June 18, almost three weeks after the actual disappearance of Laura Foster. Did the jury members know something that was not recorded in later trial testimony, or was this just another mistake? The statement seems to contain a lot of unnecessary "legalese" and a lot of repetitions just to say that the grand jury found "probable cause" that Tom Dula could be tried for the murder of Laura Foster. Why was the value of the knife important enough to be mentioned? How did they know that Tom used his right hand? No witnesses saw him commit the crime, and he denied having anything to do with it at the time. The grand jury also found that Ann could be indicted as well, but for the lesser charge of "inciting and assisting in the murder." The head prosecutor, W.P. Caldwell, later dropped the charge against Anne Melton for being an accessory to the actual murder. Presumably, he was aware of her alibi for the day the witnesses established that the murder occurred.

It is presumed from this document that Tom had been disarmed of his knife, and it was held as evidence. He was known to have carried a six-inch Bowie knife in his jacket pocket. Though not unusual for a man to carry such a weapon, it was not mentioned in the trial except in testimony about the day Tom left for Watauga County, when it was suggested that

he retrieved a knife from Ann Melton the night before he left. Could this have been the murder weapon? Again, no discussion of the knife was recorded in the trial summaries.

Sheriff W.G. Hicks then brought Tom and Ann before the bar, and the grand jury indictments were read to them. They both pleaded not guilty, and the trial preparations began. Tom and Ann were returned to their cells, where they were held without bail until the trial. Tom clearly was a flight risk and denied bail, but why Ann was not afforded bail was not explained. Perhaps she was regarded as a threat to some of the witnesses, particularly to Pauline Foster, whom she had reportedly threatened.

CHANGE OF VENUE

On Thursday, October 4, the trial began. Head counsel for the defense Zebulon B. Vance requested a change of venue. The affidavit stated, "Thomas Dula and Ann Melton make oath they do not believe they could have a fair trial in the county of Wilkes for the reason that the case has been much conversed in said County."

The evidence suggests that they were right. The case had been the talk of the town in the neighborhood of Elkville, and in Wilkes County in general, but that the case should be less well known in Iredell County, which is adjacent to Wilkes, seems unlikely. The more likely reason for the change of venue request is that former governor Zebulon Vance wanted to move the trial to Statesville because of that city's more favorable opinion of him. In 1864, he had lost the gubernatorial election in Wilkes to William Holden, but he won by a landslide (1,162 votes for Vance, 97 for Holden) in Iredell County. Vance had moved the governor's office to Statesville just before the end of the Civil War and perhaps still held property there. However, it is just as likely that the change of venue was the sole decision of the judge, who knew that he would preside over the case in Iredell as well because the fall term in Wilkes was completed and he would move with the case to Iredell.

The court ordered the trial transferred to Iredell County and the court date to be the first Friday of the Iredell fall term of 1866. Sheriff Hicks was ordered to deliver Ann Melton and Tom Dula to the sheriff of Iredell County on Thursday before the court term was to begin. Tom and Ann were transferred to the Statesville Jail, and Tom Dula never saw his native county again.

Record of Tom Dula's and Ann Melton's change of venue to the Statesville Jail from Wilkes on October 2, 1867. *Courtesy of WV/TDM.*

One of the interesting points about the change of venue was that Tom signed the affidavit with his mark (an X), as he had done one year earlier when he signed his oath of allegiance to the Union. He had made his mark at the time he was released from the Point Lookout POW camp. He did, however, scribble "Dula" above the mark where his name had been incorrectly spelled as "Dooley."

It seems that the jail in Iredell was regarded as somewhat inadequate to hold a prisoner with the reputation that Tom Dula had gained. The sheriff of Iredell and the prosecution asked the judge to provide for more security to ensure that Tom Dula remain in captivity. He had fled from Wilkes County before his arrest and had attempted to escape after his arrest. The court's ruling was the following:

> *It appears to the satisfaction of the Court that the insecurity of the jail of said county* [Iredell] *requires an additional guard for the safe keeping*

of the prisoner Thomas Dula in said prison. It is therefore ordered by the Court that a guard [force] of 8 men be allowed the sheriff of said county for the safe keeping of the prisoner Thomas Dula.

Records indicate that Tom was held in the local prison, while Ann was kept in the county jail. Tom was held in leg irons even in his cell and was kept under guard as well. He obviously was viewed as a dangerous and desperate character.

THE TRIAL AND THE APPEAL

The fall term for the Iredell County Superior Court opened on Monday, October 15, and the Tom Dula case was brought before Judge Buxton on Friday, October 19, as ordered. The sheriff was ordered to gather a group of one hundred freeholders (men who owned property) to meet at the courthouse on Friday at 10:30 a.m. Twelve acceptable jurors were selected from this pool to try the case. They were presented with the details of what had happened in court in Wilkes County, including the Bill of Indictment. The first action of the defense was a request that the case against Ann Melton should be separated from the case against Tom Dula. The reasons given were that if the two of them were tried together, Ann might confess to something that could prejudice the jurors against Tom Dula. The reasoning was that Ann was charged with "instigating and inciting" Tom to commit the murder, and if he were not guilty of the murder, then there could be no valid charge against Ann. The severance request was granted, and it was also decided that the case against Tom Dula should be tried first for the same reasons. However, Ann was to be kept in the Iredell County jail during the time Tom was being tried and until her own case was brought before the court. During the proceedings against Tom, she was allowed to be present in court but never testified. That, of course, was her constitutional right protecting her from self-incrimination.

The lead prosecutor in the case was Walter M. Caldwell, district attorney of the Sixth Judicial District. He was assisted during the trial by John M. Clement, a local lawyer. Clement spent one term in the state legislature, and in his last years as a prosecutor, he refused to prosecute cases where the death penalty was a possibility. The second assistant was Nathaniel Boyden. The latter was a veteran of the War of 1812. He served in this war despite

being only sixteen. In 1822, he moved to North Carolina and began to study law. In 1838 and 1840, he was a member of the North Carolina House of Commons, and in 1844 he was elected to the North Carolina State Senate. In 1846, he was elected to the United States Congress as a Whig. He didn't run for reelection in 1846 and returned to his law practice. After the Civil War, and actually after the final conclusion of the Tom Dula case in the fall of 1868, he was once again elected to the U.S. Congress, this time as a Conservative. In 1872, he was elected as an associate justice of the North Carolina Supreme Court. As previously noted in the section about the grand jury hearing, he later defended (the appointed) Governor Holden during his impeachment trial in 1871.

The team for the defense continued to be led by former governor Zebulon Baird Vance. He was assisted by Richard M. Allison, a resident of Iredell County. Allison was the county attorney of Iredell County before the Civil War. During the Civil War, he served as captain of a cavalry company, and after the war he resumed his law practice. Captain Allison was the man behind two of the articles (VII and VIII) of the impeachment charges against Governor William Holden. The second assistant was Robert F. Armfield, who was admitted to the bar in 1845. During the Civil War, he was a lieutenant colonel in the Thirty-eighth Regiment of North Carolina State Troops. After being wounded, he returned home and served as state solicitor for the Sixth Judicial District but was later removed by Governor Holden. After the war, he returned to a law practice in Statesville. After the Dula case concluded, he was elected to the North Carolina Senate in 1874 and 1875. He also served as lieutenant governor of North Carolina in 1875 and 1876. From 1879 to 1883, he was elected a representative to the United States Congress (as a Democrat), and later he was appointed a judge of the Superior Court. Clearly, the Dula murder trial was a case to be tried by very capable teams of lawyers, and the defense was to be paid by the state. Tom Dula was declared indigent (without funds), so the team for the defense had to be motivated by more than Tom's innocence or guilt. Political considerations appear to have played a significant role. James Isbell stated that he had assisted in employing the prosecution.

During the two trials, approximately eighty-three people testified, but unfortunately, summaries of the testimonies of only about twenty people remain. Of those on record, fifteen were witnesses for the prosecution, and only five testified for the defense. The verbatim testimonies were not recorded, and only summary transcripts that were made by the clerk of the court and the presiding judge still exist. Those summaries were produced when the case

was appealed to the Supreme Court. A lot of the testimonies are missing, and one would assume that more than five people actually testified for the defense. Why Judge Buxton chose to leave out those testimonies is impossible to tell today, but for whatever reason he did not include them.

The first trial ended with the jury deliberating all night. Early Sunday morning, it announced that it had arrived at a verdict of guilty. Judge Braxton sentenced Tom Dula to death by hanging, the sentence to be carried out on November 9, 1866. Tom's defense team immediately called for an appeal to the Supreme Court, and the appeal was granted. The Supreme Court justices found that errors had been made during the first trial and ruled that Tom Dula should be granted a new trial.

There were about four errors cited in the trial, some minor grammatical errors, but the major point was the admission of hearsay evidence. The issue was whether the testimonies of Betsy Scott and Betty Scott about their conversations with the victim Laura Foster were admissible. The conversations could not be established as true, so the parts placing Tom Dula at (or going to) the Bates Place to meet Laura Foster were challenged. The admissibility of Pauline's testimony about Ann Melton's statements and actions was also challenged.

The Supreme Court left it to the judge to decide the admissibility of Pauline's statements. A second trial before the Superior Court of Iredell was granted for Tom Dula, and his and Ann's second appearances in the Statesville Court were rescheduled.

THE SUBSEQUENT TRIALS

The next court appearance took place in the spring term of 1867 on April 15. Judge Robert B. Gilliam was now presiding. This trial came to a quick end when the defense presented an affidavit that stated that Tom and Ann couldn't come safely to trial because three witnesses were missing. The three witnesses were F.F. Hendricks from Caldwell County (one of the many Hendrickses in the area) and Francis Farmer and Mary James, both from Watauga County. None of the three testified in the first trial, but the defense must have found them important. The judge postponed the trial to the fall term of 1867, and Tom Dula and Ann Melton both remained in the Statesville Jail.

On October 14, during the fall term, Tom Dula was once again brought to court before Judge Alexander Little. This time, the prosecution presented

an affidavit stating that three witnesses, essential for its case, were not present. The witnesses were James Simmons and Lucinda Gordon, neither of whom testified during the first trial, and also James Grayson, who was, at that time, attending an assembly of the Tennessee legislature, of which he was a member. Once again, the trial was postponed, this time to the spring term of 1868.

Today, it is still not known why these missing witnesses were so important to the case because they apparently did not testify in the final trial. These postponements are somewhat mystifying. If their testimonies were so important that the trial had to be postponed twice because they were not present, why was their testimony not recorded in the final trial? It is unknown if they actually testified because the records contain only a summary transcript of the most important witnesses in the final trial.

Tom Dula was held in the Statesville Jail during this time, which was confirmed by a note in Sheriff William Wasson's notebook from October 21, 1867. In this journal, he names the prisoners incarcerated in his jail. Among the five prisoners he mentions is "Thomas C. Duly, age 23, (Charge) Murder." Ann Melton is not listed as a prisoner, so likely she was not actually kept in the Statesville Jail but at some other place, likely the lower-security county jail.

FINAL TRIAL AND APPEAL

The backlog of cases apparently had overwhelmed the court in Iredell County, so a special court of oyer and terminer (a court to "listen and decide") was appointed by the governor to try the capital and other cases that fell under the jurisdiction of the Superior Court but had not been completed. Before this trial was scheduled, Robert F. Armfield left the defense team and was replaced by David M. Furches. Furches was a prominent member of the Republican Party, which was unusual because all the other members of the defense team were Democrats. He had studied law under Richard Mumford Pearson, the Supreme Court justice who had deliberated the first trial appeal and would also hear the appeal after this trial, should it be necessary. Later, Furches was appointed a Supreme Court justice himself in 1894, after having lost the election of 1888 to Ralph Buxton, the presiding judge in the first case against Tom Dula. Furches served as chief justice of the Supreme Court from January 1901 to January 1903. Furches had moved to Statesville in 1866 and remained there for the rest of his life.

To preside over the court of oyer and terminer, Governor Holden appointed Justice William M. Shipp. Shipp had been a lawyer since 1843 and had served as captain in a volunteer regiment at the beginning of the Civil War. However, in 1861 he left the Confederate army when he was elected a state senator. In 1862, he was elected judge of the Superior Court and served as such until sometime in 1868, after the second Dula trial was concluded. Later, in 1870, he was elected attorney general of North Carolina and served one term before returning to private practice. The point here is that Tom Dula continued to be defended and prosecuted by prominent attorneys despite being unable to pay for his defense. There appeared to be political overtones as well as widespread publicity for this case.

The court of oyer and terminer opened on Monday, January 2, 1868, and on the second day the Dula case went to trial. The same testimony from the first trial was presented to a new jury, without the testimony objected to in the first trial. Again, Tom Dula was found guilty as charged and sentenced to be hanged on February 14, 1868. The defense again appealed the case to the Supreme Court, but this time no errors were found. When the case was appealed, only the material from the first trial in 1866 was resent to the Supreme Court. The Supreme Court rejected the submitted material and requested that the Iredell clerk of court, C.S. Summers, make a new summary of the last (second) trial with the collaboration of the presiding judge, William M. Shipp. This summary was prepared and sent to the Supreme Court and apparently satisfied the Supreme Court judges, for the justices made a ruling based on this revised material. This time, the Supreme Court found no reason for another trial. The date set for Tom's hanging had already passed, however, and a new date had to be set. The new sentencing required another judge and therefore had to wait for the convening of the spring court term of 1868. On April 13, 1868, Judge Anderson Mitchell set the date and time of Tom Dula's execution to Friday, May 1, 1868, between noon and 4:00 p.m.

The Prelude to and the Hanging

After the date and time of the execution had been set, Tom stayed in jail in Statesville for the next three weeks. The day before his execution, Tom's sister sent him a note from their mother. An article in the *Wilkes Recorder* on

July 18, 2001, believes it to be from his sister Anna, who was married to Micajah Hendrix. In the note, Tom's mother Mary asked Tom to confess the truth of his actions for her sake, but he did not reply. Tom requested that his sister be allowed to visit him, but his request was denied. Some records say it was the other way around—she requested to see him, but he refused to see her. This seems more likely because a dying man's last request, within reason, was usually granted.

On the evening of April 30, Tom had his dinner, and when the jailer was about to leave the cell, he discovered that Tom had managed to loosen his shackles by filing through the chain with a piece of glass he had hidden in his bed. When the loose shackles were discovered, Tom claimed that they had been loose for almost a month, perhaps to imply that he hadn't done it in an attempt to escape but rather for comfort. The shackles were repaired or replaced, and the jailer left his cell with Tom secured. Sometime in the evening, Tom summoned his defense assistant Richard M. Allison. He spoke with Allison and either dictated or gave him a piece of paper with the simple statement: "Statement of Thomas C. Dula—I declare that I am the only person that had any hand in the murder of Laura Foster."

It was dated April 30, 1868. He likely asked Attorney Allison to witness the statement. He also handed over to Allison a fifteen-page handwritten document that was a statement of his life. Both were written with a pencil in a "crude handwriting." Tom requested that Allison swear that he would keep the confession a secret until Tom was dead. Writing the note and the fifteen-page statement on his life, even in crude handwriting, was a great feat by a man who had been portrayed as illiterate. He presumably was not even able to sign his own full name on the affidavit asking for a transfer of his trial to Iredell County just eighteen months earlier. Tom had been imprisoned for the whole time and somehow had become partially literate. Unfortunately, none of those original documents is known to exist today. Census records and Wilkes School census listings indicate that Tom attended school, but how far he went is not known.

According to an article in the *New York Herald*, Tom seemed nervous and was pacing the floor of his cell during the night "as far as his chain would reach." He had tried to sleep, but he managed to sleep for only about thirty minutes. In the morning, he sent for and consulted with his "spiritual advisers," but even to the minister he denied having anything to do with the murder of Laura Foster. A Methodist clergyman baptized him, and from that time on, he engaged fervently in prayer, according to the *New York Herald* article. At his final appearance before Judge Anderson Mitchell on April 13,

1868, in order to set a date of execution after the last unsuccessful appeal, the judge had made the following statement:

> *The prisoner were…to remain in jail until Friday, the First of May AD 1868, and on that date he be taken by the Sheriff of said County [Iredell] to the place of public execution of said County between the hours of 12 o'clock and 4 pm, and there be hanged by the neck until he be dead.*

Unfortunately, there was no public place of execution in Statesville, but the sheriff had erected a simple gallows near the railway depot just south of town, a place commonly known as the "circus lot." The location of the gallows where Tom Dula was to be executed was across the railway tracks behind the new railway depot built in 1906 at 111 Depot Place (it presently houses the Statesville Convention and Visitors' Bureau). This would locate the gallows close to present-day South Center Street in Statesville. From the jail on Broad Street, Tom was to be transported a little over half a mile to the place of execution. Unlike what is claimed in several of the ballads and poems, Tom was not hanged from an "old oak tree" and definitely was not hanged in a "lonesome valley."

By 11:00 a.m. on the day of execution, the streets of Statesville were already crowded with people. Some sources spoke of as many as three thousand people, but that may have been exaggerated. An extraordinary number of the crowd was female, according to the *New York Herald* journalist, who added that most of them were in town to shop because it was the traditional day (Saturday) to come to town. Still, a certain class of people came just to watch the execution. As a matter of fact, there were so many people present that the sheriff had to appoint extra guards just to keep order in the crowds, and he ordered the local bars to close in an attempt to avoid drunkards who might make trouble. At the actual place of execution, people were climbing the trees to get a better view, and there appeared to be an equal number of males and females present. Here, the *New York Herald* reporter gets a little carried away with his rhetoric:

> *The opinion of all was that he was a terrible, desperate character, and from their knowledge of his former career an anxiety and singular curiosity was excited among them to see how he died. Few there were who decried him dying, as they believed him guilty, without [having made] a confession, and none sympathized with him.*

At 12:42 p.m., the guard was formed, and Tom Dula was led from the prison by Sheriff Wasson and some assistants. Tom climbed into the cart that also carried his coffin, and his sister and brother-in-law accompanied him.

The wagon was followed by people on foot, on horseback and in carriages as it moved through town. On the way, Tom conversed with his sister Anna E. Dula Hendricks, telling her not to worry as he had made his peace with God. Some writers have said it was his sister Eliza and her husband, but Eliza never married, and Tom's other sister, Sarah C. Dula Fletcher, lived in Boone in Watauga County and did not attend the trials and the execution.

Sheriff Wasson had erected a simple gallows consisting of two uprights, ten feet apart, with a single crossbar on top to which the rope had been fastened. When the cart arrived at the place of execution at 1:08 p.m., men on horseback had to spread the crowd in order for the cart to get through. The cart was placed under the gallows, and Sheriff Wasson placed the noose around Tom's neck. Tom reportedly said jokingly, "If I had known you were going to use such a pretty new rope, I'd have washed my neck." Sheriff Wasson then told Tom that he could address the crowd if he wanted to. A lot of people expected to hear him confess and repent, but that was not to be. Tom spoke in a loud voice that "rang back from the woods, as if a demon there was mocking the tone and spirit of a wretch who well knew he was going into eternity with an un-confessed murder upon his mind, and falsehood on his lips," according to the *New York Herald* reporter. Tom spoke of his childhood, his parents and his career in the army. He spoke of politics and claimed that the governor, William Holden, was a secessionist who could not be trusted. He didn't speak of the murder but for some reason told the crowd about the roads leading to the place of the murder and, sworn by God, that some of the witnesses at his trial had sworn falsely against him, especially in the testimonies of his whereabouts Thursday and Friday. One man in particular was mentioned, namely James Isbell, whom Tom claimed was prejudiced against him and had perjured himself during the trials. He concluded his hour-long speech by declaring that, without the lies sworn against him at trial, he would not have been standing there at all. So he maintained his public claim of innocence to the last possible moment. Tom, in one last denial, reportedly said, "Gentlemen, do you see this hand? Does it tremble? I didn't hurt a hair on the girl's head."

When he concluded his speech, he said goodbye to his sister, and the end of the rope was tied to the crossbeam of the gallows. At 2:24 p.m., the cart was pulled away, and Tom fell about two feet. His neck didn't break from the fall, and he breathed for about five more minutes, hanging from the rope

Tom Dula's original headstone that was replaced by a granite monument in 1959. *Courtesy of WV/TDM.*

Tom Dula's monument and grave site located on the east side of the Yadkin River and just above Tom Dula Road, near Ferguson. The grave is on private property and is no longer available to the public because of vandalism to the headstone. *Author's collection.*

A bronze marker installed at Tom Dula's grave, commemorating his service in the Confederate army. *Author's collection.*

without any struggling. After about ten minutes, his heart stopped beating, and at 2:37 p.m. the local physician, Dr. Campbell, declared him to be dead. Twenty minutes later, his body was taken down, put in the coffin and handed over to his sister and brother-in-law.

Tom Dula's body was taken back to Elkville and buried on land belonging to his cousin Bennett J. Dula II. That land once belonged to his grandfather, Bennett J. Dula I, and is close to what is now North Carolina Route 1134, which has been renamed as Tom Dula Road. The grave site is across and beside the Yadkin River, about a mile and a half from the cabin where Tom lived with his mother and sister. Access to the grave site is no longer available to the public because visitors were defacing the headstone seeking souvenirs.

ANN MELTON'S TRIAL

After Tom Dula was hanged and his body taken back to Elkville in Wilkes, the defense agreed to return Ann Melton to Wilkes for what was expected

to be a brief trial. Since Tom had confessed and stated that he was the sole perpetrator of the murder, it was expected that she would be released. She would be tried at the Fall Term of the Superior Court back in Wilkes. At the fall term of 1868, Ann Melton was finally put on trial in Wilkesboro. The case was transferred back to Wilkesboro likely for financial considerations. There would be no reason for Wilkes to continue to pay Iredell for her incarceration. Unlike Tom Dula, Ann was not insolvent or without means. The trial was very brief because of Tom's sworn statement to Richard Allison, and Ann was found not guilty as an "accessory before the fact" to murder. She was then released and returned to her home on the Reedy Branch. John Foster West quotes an article published in the *Statesville American* on November 8, 1868:

> The Trial of Ann Melton, charged as an accomplice to the murder of Laura Foster, took place at Wilkesboro, at the later term of the Superior Court [fall term of the Wilkes Court], and she was acquitted. The unfortunate woman has suffered about two years imprisonment, and if guilty, she has been severely punished, and the gallows would have added little to her punishment. Thus ends this woeful tragedy.

This article seems to suggest sympathy for Ann's plight and that, even if guilty, she had been punished enough. It is unlikely that the good people of Wilkes would agree with that opinion. Certainly, to this day, many would offer the opinion that she was as guilty as Tom and should have been punished accordingly. However, the court had spoken, and Ann was returned to her former life. Not much is known about Ann Melton's brief life after the trial. She returned to James and her daughter, Martha Jane. According to the 1870 census, the three of them were living together at that time, and in February 1871, Ann gave birth to a second daughter, Ida V. Melton. Ann was shunned in the community in which she lived because of the Tom Dula and Laura Foster affair. It was reported that she continued living well and did not seem to mind the local opinions of her. Ann is known to have died sometime between 1871 and 1874.

Exactly how she died is not known with certainty. The legends may very well be correct—that she died from injuries suffered during an accident with an overturned ox cart or buggy. Some stories even place the accident on present-day Gladys Fork Road (formerly the Stoney Fork Road), which passed near her home. John Foster West, in his *Lift Up Your Head, Tom Dooley*, mentions that she may have died from third-stage syphilis, even though he

The Old Melton Cemetery where Ann Melton and about twenty other Melton/Foster family members are buried. Most of the graves are marked with unlabeled markers. *Author's collection.*

admits that the period from when she was infected until she died was too short. However, he claims that her alleged delusions on her deathbed were consistent with neurosyphilis in the terminal phase of the third stage.

That conclusion seems unlikely because she was being treated for the disease before and perhaps during her incarceration. She lived about six years after Tom's hanging and gave birth to a second child in 1871. There was no evidence that either James or the child ever contracted the disease. More likely, she was cured of the disease, and her death was a result of complications from the internal injuries that she sustained in the accident. Ann Melton is buried in the Old Melton Family Cemetery on the ridge above the place where her mother's cabin once stood, just off present-day Gladys Fork Road.

In January 1875, the now widowed James Melton remarried, to Louisa Gilbert, and they had three additional children after the marriage. James Melton lived a long and productive life as a cobbler, carpenter and wagon maker. He was well liked and much respected in the community in which he

The original field stone marker of Ann Melton's grave. It was replaced with a monument by family members in 2012. The shoe lasts were used by James Melton to make shoes. *Courtesy of WV/TDM.*

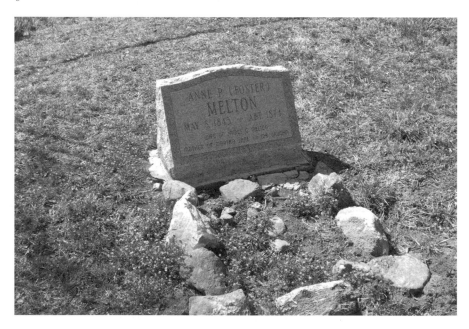

Ann Melton's monument, installed in 2012 by relatives Tony and Tom Foster and Robert and Dr. John E. Fletcher. The three graves of the "Eternal Triangle" are now marked with monuments. *Author's collection.*

lived, as were Ann's children, Jane and Ida. Some years after Ann's death, James and Louisa moved to the Yadkin Valley in Caldwell County, where James died sometime after 1912.

It seems that the children's mother's indiscretions did not adversely affect their later lives. Martha Jane married a local man, Edmund Columbus Allen, before her father moved to Caldwell County, and they lived for a time in Watauga County but returned to the Reedy Branch area later in life. (Their first child, Bettie Ann Allen, was the author's grandmother.) Ida moved to Caldwell with her parents and married there. The

James Gabriel Melton wearing his Confederate medal, circa 1890. *Courtesy of WV/TDM.*

children and grandchildren of Ann and James Melton were well liked and respected in their respective communities. Perhaps that is a tribute to their father and stepmother, Louisa Gilbert Melton.

This completes the narrative version of *The True Story of Tom Dooley* as it can be known from the existing records. But as also described in others' writings, this may not be the "whole truth" about the matter. There is a lot that cannot ever really be known about who killed Laura Foster and why after the passage of so much time. A further discussion of the evidence and the circumstances of the trials are given in a later chapter. Attention is now directed to the events and factors surrounding the trials of Tom Dula. A fresh look at the evidence and a discussion of the myths and legends resulting from the trials are offered, and finally, a brief discussion of the ballads that resulted from this story is presented.

Chapter 3

THE ADULTERY

Lots of rumors and myths surround the allegations of adultery on the part of Ann Melton. The only direct testimony at the trial was the statement of her mother, Carlotta "Lotty" Foster. She said, "Two years before the war, I saw Anne Melton, after she was married, in bed with Tom Dula. I recognized him—he jumped out [of bed] and got under the bed. He had his clothes off." She apparently chased Tom out of Ann's house and scolded her daughter for engaging in such illicit activity.

Angeline Pauline Triplett (aka Anne Foster) was married to James Gabriel Melton on June 22, 1859. They do not appear in the 1860 census records, although they are believed to have been living in the area during this time period. The Civil War, for the state of North Carolina, began in May 1861, when North Carolina finally voted to secede from the Union. Note that the Meltons' marriage was almost exactly two years before the war officially began. The question arises: what was Lotty's perception of two years before the war? It would seem that her statement or her perception of the wartime was in error, or the transcriber misstated what she said. Her statement would put Anne in bed with Tom Dula at or shortly after the time she married James Melton. While that is certainly possible, more likely she was relating an event that took place two years before the effects of the war came to North Carolina and therefore to Wilkes County. No significant battles were fought in North Carolina until well into 1862, and most of the land battles were in 1864 and 1865, resulting from Sherman's march from the South. Quite possibly, Lotty was referring to two years before "the war came" rather than

Pinkney A. Foster, brother of Ann Melton, and a woman believed to be his mother, Carlotta "Lotty" Foster. The woman on the right is unidentified. *Courtesy of Larry and Violet (Foster) Carpenter.*

two years before North Carolina's secession. Being illiterate, and living in the foothills of Wilkes, she would not have been keenly aware of national events unless they manifested themselves locally.

In mid-1859, the Meltons (James and Ann) were newly married, and Ann would have been adjusting to her new life with James. Shortly after their marriage, the couple could have been in Brunswick County, where James was learning the cobbler's trade from his relatives. About one year later, in May 1860, Ann became pregnant with her first child, Jane, who was born in mid-February 1861. Thus, mid-1859 to mid-1861 would seem an unlikely time to resume a premarital and adulterous affair with Tom Dula. Is it possible? Of course, but the following is the more likely sequence of events.

James G. Melton was enlisted into the Confederate army on June 12, 1861, only four months after the birth of his daughter. Ann Melton was left alone with a four-month-old baby, a farm and her husband's business to manage and no male figure in her life. Her supposed father had disappeared about 1848–49, and only her mother was left as her support group. This was the more logical time for the young Tom Dula to reenter her life. This time is also about two years before the events of war came to North Carolina. At only age eighteen, and having just recovered from childbirth, she would still

be physically attractive to local males. This would be the opportune time for her childhood friend and perhaps previous sexual partner to reenter her life. It is also a time when her mother would have stopped in, unannounced, and found them in a compromising situation.

It is not known how long or if the affair continued, but Tom Dula certainly temporarily ended his participation when he enlisted in Company K, Forty-second Regiment, North Carolina Infantry, on March 15, 1862. This was nine months after James Melton enlisted, and Tom was a few months shy of his eighteenth birthday (June 20, 1866). He probably could have been exempted, as his mother, now a widow, already had both of her older sons, William L. Dula and John R. Dula, as Confederate enlistees. John died in 1862 of pneumonia, and William was away fighting in Virginia. However, Tom wanted to serve, and he chose to leave Ann and his mother for military service. That enlistment left both Mary Dula and Ann Melton without a male at home.

Colonel James Isbell tried to enter additional comments about Ann's sexual behavior during his testimony at the trial. He said that "it was generally reported [gossip] that Ann Melton had engaged in illicit intercourse with others besides the prisoner." He admitted that he had assisted in employing counsel for the prosecution and that "he had no feeling of sympathy for the accused." He added that he was "only influenced by consideration of the public good." His statements were admitted, but they were clearly hearsay evidence and were not corroborated by any other testimony. Tom, at his hanging, railed against Colonel Isbell as one who had lied in his testimony in order to have him convicted. It seems clear that he was, at best, a biased witness.

Pauline Foster, of course, was the chief witness to Ann's adultery with Tom Dula after he returned from the war. It was not established when the affair resumed, but it clearly was ongoing when Pauline came to live with the Meltons in early March 1866. Pauline stated that Dula was there when she arrived and that he was there almost every day. He occasionally stayed overnight, sleeping with Ann's husband, James Melton, who was not sleeping with his wife. She stated that there were three beds in the one-room cabin, and James and Ann slept in separate beds. She did not give a reason why they did not sleep together. Not mentioned in any testimony was the fact that there was also a young daughter in the household. Martha Jane would have been five years old when Pauline came in March 1866. It is presumed that she slept in one of the beds, perhaps with her mother. Pauline stated that sometimes Ann would sleep in the bed with her, and on occasion, when Dula stayed overnight, he would come into their bed after James had gone

to sleep. James either was not aware of his wife's extramarital exploits or tolerated them to keep her happy. He was known to adore her and would do whatever was necessary to keep her happy. He also seemed to be friendly with Tom Dula, perhaps from having known him all of his life and knowing that Ann was extremely fond of him. Thomas Caleb Dula and Ann Foster Melton had grown up together and had lived on nearby farms near the Reedy Branch–Yadkin River junction. Her mother was living there with her husband's maternal grandparents, along with her three children, in 1850. Her husband and Ann's father was not listed in the household at that time.

The testimony about sleeping arrangements in the Melton and other local cabins cannot be taken literally as illicit "freeloveism," as the *New York Herald* reporter implied in his 1868 article. It was customary for persons to share beds with visitors, particularly if they were relatives, because there were no other accommodations available. Cousins often slept together in beds when visiting their relatives, and adults would also share beds or sleep in the same room on pallets or straw mats on the floors. After all, it was either that or sleep in the barn or outdoors. Many of the Hill

A reproduction of a one-room Wilkes County log cabin located on the site of the James Melton home in the Reedy Branch area of Wilkes County. *Courtesy of Daniel Boone Park and author's collection.*

A typical example of a Reedy Branch log cabin, circa 1860. *Courtesy Daniel Boone Park and author's collection.*

Country cabins were only one room affairs, so separate sleeping rooms were seldom available.

Pauline stated that she slept with Ann's brother Thomas when he sometimes stayed overnight. However, she denied having an illicit relationship with him. Wilson Foster also had stayed overnight with James Melton's brother Francis Melton, and there were others who stayed overnight after gatherings where drinking and clog dancing had been the gathering activity. The point here is that sleeping arrangements should not be taken as definite indications of an illicit relationship. Pauline Foster admitted to "sleeping" with Tom Dula in a barn and spending the night in the woods with him and George Anderson but denied having an illicit relationship with either of them. Her purpose was to distract others from Ann's real illicit relationship with Tom Dula. She did it "on a blind," at Ann's request. What is clear from the testimony is that Ann Melton and Tom Dula were in a continuing adulterous relationship while he was also having illicit relationships with other local women, including Laura Foster. There was, however, no firm evidence that Ann was involved with anyone else in the Elkville community. Ann's jealousy and the subsequent sexually transmitted disease was the primary motivation for the murder of poor Laura Foster.

Other writers have speculated on the parenthood of Ann's daughter Martha Jane because of Ann's mother's statement about her affair with Tom

Dula. However, a simple comparison of the photos of Martha Jane and her father, James Melton, clearly indicates that he is her father. She had almost identical facial features to those of her father. There can be little doubt, in the absence of a DNA test, that she was James's daughter. Some writers have speculated that James was impotent after he returned from the war as an explanation of why he did not sleep with Ann. However, he fathered a second daughter, Ida V. Melton, with Ann in 1871, and after Ann died, he fathered additional children with his second wife, Louisa Gilbert.

Chapter 4

The Pox

A central issue in the Laura Foster murder case was that of a venereal infection that plagued the principals. The prosecution made it a central issue in the charges and maintained that revenge for transmitting the infection and jealousy were the motives for the murder of Laura Foster. The various accounts, some just hearsay, have ascribed the person responsible for the initial infection as Ann Pauline Foster, who was known to have had the disease when she came to Wilkes County for treatment. However, it is also known that Laura Foster had the disease, and Tom Dula and Ann Melton both became infected with the disease between March 1 and April 1, 1866. Some authors have attempted to "prove" that Pauline was the source of the infection, and not Laura Foster, as Tom Dula and Ann Melton believed. To shed some light on this matter, we first have to know something about the disease and its progression after the initial infection.

PRIMARY STAGE ONE OF SYPHILIS

Most people with syphilis get their first symptom anywhere from ten to ninety days after infection (the average is twenty-one days). This primary stage of infection is the first of three stages. The most obvious symptom is usually a single, small, firm, round, painless sore called a chancre (pronounced SHANG-ker). The chancre usually appears where the body was first infected, which for

a woman is usually the vulva, vagina and anus or rectum. But the sores can also show up on the cervix, mouth, tongue, lips or any other part of the body that touched an infected sore. A man's chancre most often appears on the penis and anus or rectum. But it, too, can form on the lips, tongue, mouth or elsewhere. About 25 percent of people will have multiple chancres. The chancre lasts three to six weeks and heals on its own. However, just because the chancre heals doesn't mean the infection goes away; 70 percent of people in the primary stage of syphilis will also get swollen lymph glands in either the neck, armpits or groin, depending on where the chancre develops. Like the sores, the swollen glands are usually firm and painless. Since a single sore is small, painless and often inside the body (like the swollen lymph glands), many people never notice this first symptom.

SECONDARY STAGE TWO OF SYPHILIS

Most people with syphilis get their second wave of symptoms anywhere from two to eight weeks after the first chancre forms. This secondary stage of infection is the second of three stages; 33 percent of people who don't treat primary stage syphilis with antibiotics stay infected with the secondary stage for up to a year. It's at this point that the bacterium has spread into the bloodstream and the symptoms can likewise spread from the initial infection.

Approximately 75 to 100 percent of people at this stage will get a rash of red or reddish-brown spots. While the rash often appears on the palms of the hands or soles of the feet, it can appear anywhere. The rash is usually not itchy and sometimes so faint that it's not noticed or is confused for the symptom of another health problem. People may still have the chancre when the rash arrives or it could already be healed. Approximately 50 to 85 percent of people will also get swollen lymph glands in either the neck, armpits or groin depending on where the chancre developed. Anywhere from 6 to 30 percent of people can get mucous membrane lesions (called mucous patches) in or on the mouth, vagina or penis. About 10 to 20 percent of people with secondary stage syphilis will develop condylomata lata, which are moist, wart-like patches on their genitals or within skin folds. There are some less common symptoms such as swollen eyes, kidney, liver, spleen, bones or joints, which could lead to more serious complications if the STD is not treated. And finally, some people may feel feverish; lose weight; get muscle aches, chills or a runny nose; and not feel as hungry as normal.

Just like with primary stage syphilis, these symptoms can all go away on their own, but that doesn't mean the infection has gone away. Typically, the infection goes to the next stage, which doesn't usually have symptoms but can lead to serious complications. Most people with latent stage syphilis have no symptoms at all.

LATENT STAGE THREE OF SYPHILIS

This third stage of syphilis gets its name from latent, which also means hidden. This is because there are usually no symptoms during the one to thirty years of this stage. For the 35 to 40 percent of people who get to this stage of untreated syphilis, this is when serious complications can begin. During the early part of this stage, some people do get symptoms from the secondary stage, but by the later stage of latent syphilis it is less likely that any symptoms will appear. If symptoms do show up, they are usually from health complications that begin with internal organs such as the brain, heart, eyes, nerves, blood vessels, liver, bones and joints. Signs and symptoms of the latent stage of syphilis include difficulty coordinating muscle movements, paralysis, numbness, gradual blindness and dementia. This damage may be serious and can result in death.

Without modern forensic methodology, it may be impossible to determine the stage of the disease that was present in Ann Pauline Foster when she first came to Wilkes. Since she was seeking treatment, it can be assumed that she was well into the first stage of the disease, knew that she had the disease and knew the consequences of not treating the disease. It is quite likely that she was contemplating marriage at that time and needed to be cured of the disease before that marriage could take place. She is believed to have had a marriage bond with John Scott that was dated January 1866, but the marriage had not taken place by March 1866. The reporter for the *New York Herald* newspaper stated that she later married after the first trial was held in 1866, but the trial documents of 1868 did not list her under her married name.

The little evidence that is available comes from the trial testimony, principally from Pauline Foster herself, and from Dr. George N. Carter, who treated all three patients—Pauline Foster, Ann Melton and Thomas Dula—for the disease. The treatment described in their testimony consisted of "blue stone,"

"blue mass" and "caustic." The effectiveness of this treatment is not known, and John Foster West has written that other treatments of that time were potassium, iodine or mercury salts—or possibly all three. It is not known if that is what Dr. Carter prescribed. Dr. Carter testified that he treated Tom Dula but did not comment on any treatment of the others. At least, no other testimony by him was recorded in the trial summaries. The blue mass he prescribed was a mixture of elemental mercury, licorice, rose leaves and honey that was taken internally. Other treatments for venereal disease were a mild chloride of mercury calomel or a nitrate of mercury applied topically. Alum was also used to treat the external lesions and sores. Pauline had testified that Tom went to the Meltons to get alum for the sores in his mouth. One would assume that those sores were symptoms of his disease.

THE TESTIMONY

Pauline Foster arrived in Elkville about March 1 to seek treatment for syphilis but did not tell anyone except Dr. Carter that she had the disease. She later testified that she contracted the disease in Watauga County and came to Wilkes under the pretense of visiting her grandfather and to find work to pay for her treatments and to get cured of the disease. It can be presumed that she saw Dr. Carter right away and began treatment at that time.

Wilson Foster testified that Tom Dula began seeing his twenty-two-year-old daughter, Laura, about two months before she disappeared. That would be two months before May 25, 1866, or about early to mid-March 1866. Wilson stated that Dula came frequently, at least once a week, and that sometimes Dula and his daughter shared her bed when he stayed overnight.

Dr. George Carter testified that about the last of March or the first of April, Tom Dula "applied to me for medical treatment. He had syphilis. He told me he caught it from Laura Foster." Note that this time frame is within the ten- to ninety-day first stage incubation period. Pauline Foster testified that Ann Melton also became sick, and the treatments she used were "blue mass, blue stone and caustic." Pauline knew that this treatment was for syphilis because she was using the same treatments. However, she did not confide in anyone that she also had the disease before mid-May. Later, on Thursday, May 24, 1866, Ann Melton confided in Pauline Foster that Tom Dula had "the pox" and had given it to her also. She told Pauline that Tom got the disease from her cousin Laura Foster and commented that she was

going "to kill her" because of it. She also threatened Pauline with bodily harm if she ever revealed what she had told her. The local expression "I am going to kill you" is not necessarily a real death threat but an expression of extreme displeasure and possibly bodily harm intended toward the person to whom it is directed.

The question is: could Tom have contracted syphilis from Pauline instead of from Laura or some other woman? Pauline Foster testified in the undated transcripts that she never "went around" Tom Dula except for "a blind," and then only at Ann's request. Ann had asked her to distract her neighbors from her adulterous affair with Tom Dula. Pauline admitted that she would "romp" with Tom and sometimes sat on his lap when other women were present at the Meltons' home. She also stated that she spent a night with him in a barn, and that she, Tom Dula and Washington Anderson had spent a night together in the woods. However, she denied having sexual relations with either of them and also denied illicit relations with her brother or with Ann's brothers (as Ann had reportedly stated to others). No direct evidence or testimony to the contrary was presented in open court. Furthermore, there were no witnesses who testified to any such incidents because neither Ann Melton nor Tom Dula testified at either trial. Washington Anderson confirmed the overnight in the woods, but his recorded testimony did not elaborate on the details.

Did Laura Foster have syphilis prior to forming a relationship with Tom Dula? The evidence is scant, but Wilson Foster testified that his daughter Laura had "boils" about her neck and shoulders and that she was taking medicine for the condition. That would indicate that she was probably in the second stage of the disease. The time of this observation was mid- to late May, before her disappearance. That would imply that she was infected by early March or before. This was about the same time that she began her affair with Tom Dula. Could he have infected her, or did she infect him, as he claimed?

Other writers have tried to claim that Pauline was the source of his infection. How plausible is that conjecture? First of all, Pauline was under treatment for the disease beginning in early March 1866. Certainly, Dr. Carter must have cautioned her not to have sexual relations with anyone until she was at least in remission or was cured. Tom Dula was believed to be Pauline's second cousin, and she was certainly fond of him as a friend and relative. She knew that Tom was frequently having sexual relations with Ann Melton, her cousin and her employer, and she knew he was also being intimate with Laura Foster and others. Would she have relations with Tom and risk losing her job, incurring the wrath of her volatile cousin Ann and

possibly infecting the two of them? This scenario seems highly unlikely. If Pauline did have any sexual relations with Tom Dula and Washington Anderson, "on a blind," as Ann reportedly requested of her, those events would have taken place well after March, when Tom was already infected and had already transmitted the disease to Ann.

It should be noted that Tom had applied to Dr. Carter for treatment about three weeks after he began his affair with Laura Foster. That time is entirely consistent with the average incubation period of the disease (twenty-one days). It is also the time period during which Tom would not likely have had any relations with Pauline Foster. The most logical scenario is, therefore, that Laura Foster was the source of Tom's infection, as he believed, and was indirectly responsible for Ann Melton's infection as well. The myths and legends associated with this story have often implied that Laura Foster was an innocent young girl Tom Dula had taken advantage of. That was certainly not the case. Laura Foster was described as "frail or fragile," not referring to her physical constitution but rather to her loose morals (i.e., her morals were "fragile"). She was also described as having "round heels," meaning that she was easily moved to a horizontal position by her male suitors. Thus, the possibility of her having acquired "the pox" before she began her affair with Tom Dula seems quite likely.

Was that a motive for murder? The principals here, Pauline, Tom and Ann, all seemed aware that if the disease were left untreated, it could result in disability and possibly death. Furthermore, it could be costly to undergo medical treatments. During the economic times of the Wilkes County of 1866, that could be an unpleasant and annoying hardship.

Pauline had also testified that Ann said she would try to fool James Melton into thinking that he had given her the disease. No testimony indicated that he had the disease or was being treated for it, so how could she have pulled this off? One did not usually contract the disease without having intercourse, and there was no evidence that James was unfaithful to Ann. Could it be that Pauline was trying to imply that Ann threatened to tell James Melton that Pauline had given him the disease? These statements add to the notion that James was unaware, at that time, of his wife's infidelity with Tom Dula. Furthermore, Ann Melton, at that time, was unaware that Pauline also had the disease. There was no reason to think that James Melton ever had sex with Pauline Foster. This part of Pauline's undated testimony seems suspect for those reasons.

Another point that denies Pauline as the source of the infection is that she came to Wilkes to get cured so that she could complete her marriage

bond. Would she have jeopardized that objective by having sex with others whom she knew could reinfect her? Pauline may have been a loose-lipped simpleton, but she was not a complete fool. To infect her only means of support would not seem worth the risk, even for the likes of Pauline. She achieved her objective of becoming cured and did later get married, as was verified by the *New York Herald* reporter. The evidence seems more than conclusive that Laura Foster was, in fact, the source of Tom Dula's and Ann Melton's venereal infections.

Chapter 5

THE TRIAL DOCUMENTS
AND WITNESSES

I n this chapter, the primary documents from the Tom Dula trials are
presented, and the primary witnesses are identified and briefly discussed.
The secondary witnesses are also listed, but their contributions to the trial
testimony are unknown. These documents are transcribed from the original
files or from exact transcriptions of the original files.

THE ARREST WARRANT

State of North Carolina
Wilkes County

To The Sheriff of Wilkes County

Greetings:
*Whereas information upon oath hath been made upon the oath of Wilson
Foster of Caldwell County that his daughter Laura Foster, late of said County
mysteriously disappeared from her home, under circumstances as to induce him
to believe that she has been murdered or otherwise foully dealt with by certain
persons under Suspicion To Wit, Thomas Dula, Ann Pauline Melton, Ann
Pauline Dula and Granville Dula, this is therefore to command you to arrest the
bodies of the said Thomas Dula, Ann Pauline Melton, Ann Pauline Dula and
Granville Dula of the County of Wilkes if to be found and have them before*

me or some other Justice of the Peace to answer the above charge and be further
dealt with according to law. Having made my hand and seal this 25th day of
June 1866.
Pickens Carter, JP [seal]

Formal legal proceedings against Tom and Ann began on October 1, 1866, when North Carolina's Superior Court met at Wilkesboro under Judge Ralph Buxton. The charges they made against Tom said he "feloniously, willfully and of malice aforethought did kill and murder [Laura Foster] against the peace and dignity of the state." Ann was charged that she "did stir up, move and abet, and cause and procure, the said Thomas Dula to commit the said felony and murder" and then chose to "receive, harbor, maintain, relieve, comfort and assist" him. In other words, Tom was accused of killing Laura Foster, and Ann Melton was charged with both encouraging him to commit the crime and assisting and harboring him afterward. The prosecution quickly agreed to drop the assisting and harboring charges against Ann, leaving just the first accusation against her.

THE BILL OF INDICTMENT

The Jurors for the State upon their oath presented that Thomas Dula, late
of the County of Wilkes, not having the fear of God before his eyes, but
being moved and seduced by the instigation of the Devil on the 18ᵗʰ day
of June 1866 with force and arms in the County aforesaid in and upon
one Laura Foster in the peace of God and the State then and there being
feloniously, willfully and of malice aforethought did make an assault the
said Thomas Dula with a certain knife of the value of five cents which he
the said Thomas Dula in his right hand then and there had and hold the
said Laura Foster in and upon the breast of her the said Laura Foster then
and there feloniously willfully and of his malice aforethought did strike,
thrust and stab, giving to the said Laura Foster, then and there with the
knife aforesaid in and upon her breast of her the aforesaid Laura Foster
one mortal wound of the breadth of one inch and the depth of six inches
of which the said mortal wound the said Laura Foster, then and there
instantly died and so the Jurors aforesaid upon their oath aforesaid, do
say the said Thomas Dula, the said Laura Foster in manner and form
aforesaid feloniously, willfully, and of his malice aforethought did kill and
murder against the peace and dignity of the state.

The Jurors for the State upon their oath accuse that Ann Melton did "stir up, move, and abet, and cause, and procure the said Tom Dula to commit the said felony and murder, and him the said Tom Dula did then and there feloniously willfully and of malice aforethought receive, harbor, maintain, relieve, comfort and assist against the dignity of the State.

That is, Tom was charged with committing the act of murder and Ann with being an accessory before the fact, (planning the murder) and after the fact (helping conceal the fact of the murder). Today, she probably would also have been charged with obstruction of justice. The prosecutor, W.P. Caldwell, later dropped the original charge against Ann Melton for being an accessory "after the fact" to the murder.

Sheriff W.G. Hicks then brought Tom and Ann before the bar, and the indictments were read to them. They both pleaded not guilty. Tom and Ann were returned to their jail cells, where they would stay until the trial began.

A strange thing here is the incorrect date in the indictment. The grand jury bill states that the murder was committed on June 18, almost three weeks after the actual disappearance of Laura. Did the jurors know something that is not known today or was this just another mistake? A second point not made in the trial was the description of the knife used by Tom in the indictment. The deputies must have disarmed Tom, taking his knife as evidence when he was arrested. However, it was not discussed in the summaries. Today, it could have been tested for traces of Laura's blood, but not then. Furthermore, Tom was never conclusively placed at the scene in the testimony summaries. Of course, none of the minor witness testimony was included, so it is possible that Martha Gilbert or one of the other witnesses who lived near the Bates Place placed him at or near the scene of the crime on Friday, May 25, 1866.

FROM THE FALL TERM 1866 COURT DOCUMENTS

The following (original 21) witnesses are bound in the sum of $100 each to appear in Statesville, NC on Thursday of said Term:
(Dr.) George N. Carter, James (G.) Melton, Wilson Foster, Calvin Carlton, Hezakiah Kendall, (Carlotta) Lotty Foster, Martha Gilbert, John (Jack) Atkins, Drewory (Drewery) Atkins, Bennett Fergurson, Pauline Foster, Celia Scott, (Margaret) Betsy Scott, (Col. James) J. M. Isbell, Carson Dula, James Foster, (George) Washington Anderson, Micajah C. Hendricks, Bennett (H.) Walsh, James Scott, J. P. Hoffman.

I certify that the above transcript is true in testimony whereof I set my hand and affix the seal of this Court this 18th day of October 1866.
G.H. Brown C.S.C

Thomas C. Dula was declared indigent (without funds) by the court, and thus his defense and appeals were to be paid by the state or were pro bono efforts by his attorneys. (Items in parentheses are corrections or elaborations of the handwritten notes.)

TOM DULA COURT DOCUMENT (1866 TRIAL)

W.P. Caldwell, Sol. (Solicitor)

The following on the back:

(NC) State	}	
vs.	} *(Charge)*	
Thomas Dula &	} *Murder*	
Ann Melton	}	

(Witnesses):

Dr. George N. Carter	*X*	*Celia (Anderson) Scott*	*X*
James Melton	*X*	*(Margaret) Betsy Scott*	*X*
Wilson Foster		*C.C. Jones*	*X*
Calvin Carlton	*X*	*J. (James) M. Isbell*	*X*
Hezekiah Kendall	*X*	*Doria (Docia) Witherspoon*	
(Carlotta) Lotty Foster	*X*	*Carson Dula*	
Thomas (Triplett) Foster	*X*	*James Foster*	
Martha Gilbert	*X*	*(George) Washington Anderson*	
John Atkins	*X*	*(Jack Atkins)*	
Dewory (Drewery) Atkins	*X*		
Bennett Ferguson	*X*		

Pauline Foster (Ann Pauline Foster (Dula))

Those marked (with an) X (are) Sworn and Sent
G.H. Brown CSC (Clerk of the Superior Court)
A True Bill
A.S. Rousseau, Foreman (of the Jury)

A handwritten trial record and witness list from the North Carolina Archives. *Author's collection.*

Only 20 of the original 111 witnesses were recalled to testify. The summaries contain only the direct testimony of these witnesses. After the trial was moved to Statesville, the authorities were concerned about the security of the jail where Tom Dula was being held. There was concern about his personality and behavior due to previous escape attempts and his reputation in the Wilkes community. At the authorities' request to the court about these concerns, the court issued the following order:

> It appears to the satisfaction of the Court that the insecurity of the jail of said county [Iredell] requires an additional guard for the safe keeping of the prisoner Thomas Dula in said prison. It is therefore ordered by the Court that a guard of eight men be allowed the sheriff of said county for the safe keeping of the prisoner Thomas Dula.

Charging Wilkes County for these eight additional guards seems like an exorbitant cost to the county unless the reputation and behavior of the prisoner justified it. There was no record of escape attempts after the trial was moved from Wilkes to Iredell. However, it seems clear that the sheriff and the prison staff were concerned with the possibility of further escape attempts.

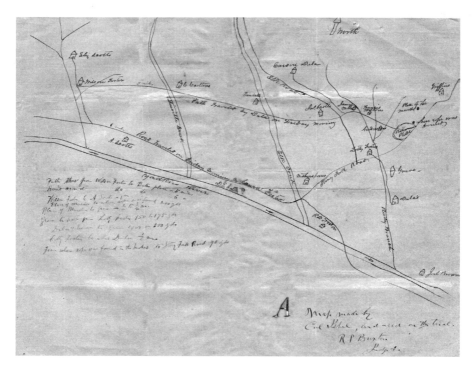

A crude map of the Yadkin Valley and the Reedy Branch drawn by Colonel James Isbell and used as Exhibit A in the Tom Dula Trials. *North Carolina Archives and author's collection.*

THE CHARACTERS OF THE LEGEND

The Accused

THOMAS CALEB DULA: Defendant, age twenty-two; childhood friend of Angeline P. Triplett; suitor of murdered girl Laura Foster; Confederate war veteran and known womanizer in Elkville, North Carolina.

ANGELINE TRIPLETT MELTON: Accessory to defendant, age twenty-three; wife of James G. Melton; involved sexually with defendant; first cousin of the murder victim Laura Foster; fourth cousin of Pauline Foster (Dula); daughter of witness Carlotta "Lotty" Foster (Triplett); sister of witness Thomas Foster (Triplett); first cousin of witness James Foster.

The Principal Witnesses

Note: Eighty-three witnesses were originally listed for the first trial, but not all of those witnesses' testimony was recorded. Only the twenty listed below were summoned to testify at the second trial.

1) DR. GEORGE N. CARTER: The only physician in the Tri-County Area of Wilkes, Caldwell and Watauga; acting coroner and examiner of murder victim's buried remains; treated Thomas Dula and Pauline Foster (Dula) and possibly Ann Melton for syphilis; wealthy landowner in Kings Creek and the husband of Juliette Jones, daughter of Catlett C. Jones and granddaughter of Captain William Dula.

2) ANN PAULINE FOSTER (DULA): The principal witness for the prosecution; relative of both defendants; resident domestic in the Melton household; state's evidence witness and original co-defendant, but charges dropped; also a fourth cousin of the murder victim. Watauga County resident and former Kings Creek, Caldwell County resident; granddaughter of John "Jack" Dula of Kings Creek, Caldwell County.

3) JOHN "JACK" ATKINS: Deputy sheriff; co-leader of arresting posse; murder investigator; also known as Jack Adkins.

4) BENNETT FERGUSON: Deputy sheriff; co-leader of arresting posse; murder investigator.

5) CARLOTTA (LOTTY) TRIPLETT FOSTER: Witness to events and mother of defendant Ann Melton and witness Thomas Foster; sister of Wilson Foster and aunt of murder victim Laura Foster.

6) THOMAS (TRIPLETT) FOSTER: Brother of defendant Ann Melton; witness to events of May 25, 1866; present at the Meltons' cabin on May 25 and 26, 1866.

7) WILSON FOSTER: Father of murder victim; uncle of Ann Melton; brother of Carlotta Triplett and complainant in murder indictment; Buffalo (German's Hill) resident of Caldwell County.

8) JAMES FOSTER: Brother of murder victim and witness to events; first cousin of defendant Ann Melton; Buffalo resident of Caldwell County.

9) JAMES G. MELTON: Husband of defendant Ann Melton and member of search parties; witness to events of May 1866; local farmer, cobbler, carpenter and wagon maker.

10) COLONEL JAMES M. ISBELL: Leader of search party that discovered murder victim's grave; constructed Exhibit A (the map of the events of May 25, 1866); also gave hearsay testimony on the characters of the defendants; friend of James Melton and owner of land near where Wilson Foster lived in Happy Valley and Caldwell County; owner of a farm where Wilson

Foster worked as a tenant farmer or sharecropper; great-grandson of Benjamin Howard, an original settler of the Yadkin Valley; husband of Sarah Horton, granddaughter of Captain William Dula.

11) CELIA (ANDERSON) SCOTT: Witness to defendant's movements on May 25, 1866. Lewis Fork resident; wife of witness James Scott; sister of witnesses George Washington Anderson and Eliza Anderson; former neighbor of Wilson Foster earlier in Caldwell County; testified to fight between Pauline and Ann Melton.

12) MARGARET "BETSY" SCOTT: Witness to events of Friday, May 25, 1866; resident of Fort Defiance in the Buffalo community of Caldwell County; mulatto woman and neighbor in Caldwell County of Wilson Foster, who conversed with the murder victim on the River Road; testified about the meeting place and destination of Laura Foster and Tom Dula; part of her testimony was later stricken as hearsay and was the main reason that Tom Dula was granted a second trial.

13) CALVIN JAMES CARLTON (1826–1880): Lewis Fork resident who witnessed the prisoner's movement on May 25, 1866; son of Wyatt Carlton; fought with the South in the Civil War; enlisted in Watauga County on September 14, 1861, at thirty-four years of age, in Company B, Thirty-seventh Regiment, known as the "Watauga Marksmen"; mustered in as sergeant; elected second lieutenant on April 16, 1862; wounded in the leg at Gaines' Mill, Virginia, on or about June 27, 1862; resigned on or about November 22.1862. (The reason he resigned is not reported.)

14) HEZEKIAH KENDALL: Elk Creek resident who witnessed the prisoner's movements on May 25, 1866.

15) THEODOCIA "DOCIA" WITHERSPOON: Elk Creek resident who witnessed the victim's movements on the morning of May 25, 1866; lived on the Stoney Fork Road near the River Road.

16) CARSON MCGUIRE DULA: Elk Road resident who witnessed the defendant's movements on May 25, 1866. (WILLIAM CARSON DULA: son of Harrison Dula and Cynthia Triplett; born January 2, 1841, in Wilkes County, North Carolina, and died May 21, 1917, in Caldwell County, North Carolina; enlisted in Company K, Forty-second North Carolina Regiment on April 24, 1862, in Wilkes County with his cousin Tom Dula; present or accounted for through October 1864; Elkville resident who supplied Tom Dula and Ann Melton with a canteen of moonshine whiskey on May 25, 1866.)

17) MARTHA GILBERT: Witness to defendant's digging with a borrowed mattock along the path near the grave of the murder victim and on the path to his residence; Elkville resident in 1866.

18) GEORGE WASHINGTON ANDERSON: Neighbor and friend of the Meltons; present at the May 25, 1866 gathering at James Melton's home; friend and fellow soldier with the defendant Thomas Dula; brother of Mrs. James (Celia) Scott and witness Eliza Anderson; Elkville resident of Wilkes County.

19) C. (CATLETT) C. JONES: Yadkin River Valley resident; possible witness to Laura Foster's movements on May 25, 1866; son-in-law of Captain William Dula and father-in-law of Dr. George N. Carter; no testimony of his was recorded.

20) DREWEY P. ATKINS: Local blacksmith; Elkville resident, age twenty-eight; possible former suitor of murder victim; reason for his summons is not recorded in any trial summary.

Officials and Hearing Sites

WALTER P. CALDWELL: Prosecuting attorney or Iredell County district attorney.

CALVIN COWEL: Owner of Elkville Post Office and meeting ground for local militia, which served as the hearing room for Justice of the Peace Pickens Carter, the location where the hearing was held for the first arrest warrant. Ann Melton, Pauline Foster (Dula) and Granville Dula were released. Tom Dula was ordered found and arrested. The inquest and autopsy were performed here after the body was found. Calvin J. Cowel came to Elkville in about 1846 and established his store here. He later sold the property and moved to Wilkesboro about 1858, but the store and location retained the name until the structure was torn down sometime after the 1870s.

DEFENSE ATTORNEYS: (First Trial) Colonel Zebulon Buxton Vance, head; Robert Franklin Armfield and Captain Richard M. Allison; (Second Trial) Colonel Zebulon Buxton Vance, head; and Captain Richard M. Allison and David Miffed Lurches. Allison received the written confession and fifteen-page handwritten life history of Tom Dula on May 1, 1868.

WILLIAM G. HIX: Sheriff of Wilkes County and official arresting officer of defendants.

WILLIAM SHIP: Presiding judge for the January court term on January 21, 1868.

C.L. SUMMERS: Clerk of the Iredell County Superior Court that wrote the trial summaries for the North Carolina Supreme Court to review.

ROBERT GILLIAM: Presiding judge at the fall of 1867 court term; issued continuation to the second trial.

TIME DATA FOR MAY 25, 1866:
Sunrise: 5:51 a.m.
Sunset: 8:27 p.m.
About fourteen and a half hours of daylight occurred on this day.

ADDITIONAL WITNESS LISTS AND PERSONS INVOLVED IN THE TRIALS (INCLUDING THE GRAND JURY AND THE FIRST AND SECOND TRIALS)

Sheriffs

R.R. Call
John Horton
William F. Watson, Iredell County sheriff

Deputy Sheriffs

Ed Brown
J.L. Lawton
P. Tomlinson
J.A. Wakefield
W.T. Watts
W. White
W.H. Witherspoon

Jail and Prison Guards

Poindexter Jones
B.F. McNeill
Thomas McNeill
Lee Sinclair

Iredell County Jailor

E. Crooner

Superior Court Clerk

G.W. Brown

Other State Witnesses
(Witnesses Who Testified or Were Mentioned in Recorded First Trial Testimony)

CAROLINE BARNES: Wife of W.W. Barnes, a farmer living in Caldwell County in 1866; born about 1840; married William W. Barnes on April 3, 1859 (In the 1860 census, they are listed in the Little River District of Caldwell County, with Deals Mills Post Office, as "W.W. Barnes, age 23, Caroline Barnes, age 20, Philip Barnes, age 6 months."); twenty-six years old in 1866; reportedly was involved with Tom Dula; not summoned to testify at trial.

MARY KEATON DULA: Widowed mother of the defendant and witness to events of May 25 and 26, 1866.

JESSE GILBERT: Witness to events of May 25, 1866; Elkville neighbor of the defendants.

JONATHAN GILBERT: Neighbor of Wilson Foster; friend of James Melton; witness to events of May 25 and 26, 1866; resident of Buffalo, Caldwell County; was working at James Melton's farm on May 25 and was present there at the evening gathering.

LIEUTENANT COLONEL JAMES W.M. GRAYSON: Large landowner on the North Carolina–Tennessee border in Trade, Tennessee, who employed Tom Dula under the false name of Tom Hall in late June and early July 1866; assisted the posse in tracking Dula's flight; assisted in his arrest in Tennessee and helped return Tom Dula to Wilkes County for trial; did not return to testify.

RUFUS DULA HALL: Witness to defendant's threat to "put through" the person who gave him syphilis; age thirty-nine; Elkville resident; wealthy landowner in Happy Valley of the Yadkin.

MICAJAH C. HENDRICKS: Elkville resident and local miller; brother-in-law of Tom Dula; member of large local Hendrix family of Elkville residents;

received body of Tom Dula after his hanging; son-in-law of Mary Dula and husband of Anna E. Dula.

FLOYD F. HENDRIX: Elkville resident and witness whose family conjectured that Tom Dula killed Laura Foster; member of large local Hendrix family of Elkville residents.

J.P. HOFFMAN: Blue Ridge of Watauga County resident and Stoney Fork–Rutherwood resident; trial connection is unknown.

WILLIAM HOLDER: Witness to events of May 25, 1866; present at James Melton's Friday evening gathering; Buffalo resident and neighbor of Wilson Foster; search party member; brother of Francis Melton's wife, Mary "Polly" Holder (also spelled Houlder).

MAJOR DAVID EAGLES HORTON: Elk Creek resident and father-in-law of Colonel James M. Isbell, search party member and initial finder of victim's grave and body; son-in-law of Captain William Dula; distant relative of Tom Dula.

RUFUS DULA HORTON: Elk Creek resident; age thirty; witness to victim's travel on May 25, 1866; character witness for Mrs. Mary Dula; son of General William Horton and grandson of Captain William Dula; owner of a large plantation adjacent to Cowel's Store and Elkville.

JOHN "JACK" KEATON: Half brother of Mary Keaton Dula and twenty-nine-year-old uncle of Tom Dula; arrested with Ann Melton after Dula's arrest in July 1866; released after producing an alibi but may have aided Tom in an attempted escape; possible other suitor of Laura Foster; may have accompanied Tom Dula to Watauga County when he left from Wilkes.

FRANCIS A. MELTON: Brother and neighbor of James Melton; witness to events of May 1866.

ALEXANDER SCOTT: River Road resident of Caldwell County and witness to victim's travel on May 25, 1866; neighbor and relative of Elizabeth "Betty" Scott.

MRS. ELIZABETH "BETTY" SCOTT: Witness to events of Friday, May 25, 1866; resident of Caldwell County who conversed with victim shortly before her disappearance; stated that Laura had told her earlier that she and Dula had planned to run away together.

JAMES SIMMONS: Neighbor of Wilson Foster, possible former suitor of victim; age twenty-eight; Buffalo resident of Caldwell County.

BENNETT H. WALSH: Elkville resident; husband of Sarah Melton Walsh, James and Francis Melton's sister; no record exists of what he may have testified about.

J.W. (JOHN WALTER) WINKLER: Leader of searches for Laura Foster's grave; neighbor and friend of Wilson Foster in Buffalo community of Caldwell County; owner of land where Laura Foster was buried.

ELIZA ANDERSON: Sister of the witness G.W. Anderson and witness Celia (Anderson) Scott; resident of Reedy Branch settlement; testified at the second trial, but testimony was not recorded; her cross-examination was the subject of a defense objection (the prosecution had tried to discredit it).

Witnesses Listed but Not Recorded in Any Testimony

D.P. ADKINS: Unknown testimony, possibly the same as Drewory Atkins.

J.H. ADKINS: Unknown testimony.

WM. ADKINS: Unknown testimony.

REBECCA ANDERSON: Unknown testimony.

JOEL H. BROWN: Reedy Branch resident; Mary Dula's neighbor; uncle (by marriage) of Carlotta Triplett; great-uncle of Ann Melton.

BOB CUMMINGS: Rumored suitor of Laura Foster; Wilkes posse member; unknown residency. This person may not exist; he was not listed in any court or local records.

ANDERSON DULA: Cousin of defendant Tom Dula; Elkville, Wilkes County resident (not the husband of Tom's sister Eliza Dula).

CYNTHIA DULA: Sister of large Dula family of the Yadkin Valley.

ELIZA DULA: Sister of the defendant Tom Dula; living at home with her mother on Reedy Branch; no testimony was recorded.

GRANVILLE DULA: Arrested on initial warrant; cousin of defendant; released after initial hearing as not guilty; Elkville resident of Wilkes County; reason for his arrest is unknown.

LUCINDA C. DULA: Elkville witness; a weaver; widow of William L. Dula, Tom Dula's brother; acquaintance of Laura Foster; later the wife of Pinkney A. Foster, older brother of Ann Foster Melton.

THOMAS M. DULA: Owner of a large plantation (1,500 acres) in the Yadkin Valley near German's Hill; reason he was called to testify was not recorded.

WILLIAM C. DULA: Possibly the same person as Carson Dula, previously listed.

FRANCIS FARMER: Watauga County resident; reason for testimony was not recorded.

MARTHA FOSTER: Younger sister of defendant Ann Melton; no testimony was recorded.

SAMUEL (TRIPLETT) FOSTER: Younger brother of defendant Ann Melton; no testimony was recorded.

TINY (TRIPLETT) FOSTER: Younger brother of defendant Ann Melton; no testimony was recorded.

WELBOURNE GERMAN: Landowner near Wilson Foster's home; founder of Cilly on the Yadkin; no testimony was recorded.

BECKIA GILBERT: Unknown testimony.

LUCINDA GORDON: Unknown testimony.

THOMAS HALL: Great-uncle of Tom Dula family members; unknown testimony.

GAY HENDRICKS: Unknown testimony.

G.W. HENDRIX: May be the same as Gay Hendrix above; unknown testimony.

LEANDER HENDRICKS: Unknown testimony.

JOHN HOFFMAN: Unknown testimony.

JAMES C. HORTON: Owner of a plantation on the Yadkin River across from Ferguson; son of General William Horton; one of the original settlers of Happy Valley and a son-in-law of Captain William Dula; no testimony is recorded.

PHINEAS HORTON: Unknown testimony.

COLONEL JOSHUA HOWARD: Unknown testimony.

MARY JAMES: Unknown testimony.

C.P. JONES: Unknown testimony.

GRANVILLE JONES: Unknown testimony.

J.G. JONES: Unknown testimony.

J.H. JONES: Unknown testimony.

LLOYD JONES: Landowner in Yadkin Valley near Wilson Foster's home; unknown testimony.

COLONEL THOMAS C. LAND: Elkville resident who wrote the poem "The Death of Laura Foster," a precursor to one of the "Ballads of Tom Dooley"; no testimony was recorded.

ALEXANDER MELTON: Possible mistaken identity; James Melton's younger brother, who died in the Civil War. If this person is correct, he did not appear at the trial and is unknown.

W.G. MELTON: Unknown testimony.

TEMPE PILKERTON: Unknown testimony.

ANGELINE P. SCOTT: Mulatto woman on the River Road; saw Laura Foster on May 25, 1866, but was not called to testify.

JAMES SCOTT: Elkville resident; husband of witness Celia Anderson Scott; no testimony was recorded.

RICHARD SWANSON: Unknown testimony.

CALVIN L. TRIPLETT: Local poet who wrote an early version of "The Ballad of Tom Dooley."

GEORGE TRIPLETT: Reedy Branch resident; possibly saw victim and defendant on the May 25, 1866.

B.H. WELCH: Unknown testimony.
LYDNEY WELCH: Unknown testimony.
FRANKLIN WEST: Unknown testimony.
COLONEL ALFRED WITHERSPOON: Unknown testimony.
LUCINDA WITHERSPOON: Unknown testimony.

This completes the documented version of *The Story of Tom Dooley*. To the best of present knowledge and records, this is the true story as it can be known today. However, the story has been reconstructed from the known testimonies, previously documented accounts and court records. It does not tell the stories of the families of Wilkes County, Caldwell County and Watauga County who were touched by the events described herein. The principals in this story were intermarried and related to a large number of families in those three counties. Who were they and how were they related? These families were the Dulas, the Meltons, the Fosters, the Tripletts and many others who had lesser connections to the principals. To paraphrase radio commentator Paul Harvey, "Now this is the Rest of the Story."

Chapter 6

THE EVIDENCE, THE TRIAL AND
THE CONCLUSIONS

In this chapter, we will attempt to view the Tom Dula trials and evidence from the point of view of a juror. All jurors from Iredell County in the first trial were presumed to have no prior knowledge of the evidence presented in the case. The prosecution stated in its opening presentations that it intended to prove the guilt of Tom Dula by circumstantial evidence. At the end of the presentation of the case, the defense asked the judge to charge the jury (for our purposes, you, the reader, and me, the author) as follows:

> *1) that circumstantial evidence must be at least as strong as the positive and direct testimony of one credible witness.*
> *2) that the circumstances proved must exclude every other hypothesis.*
> *3) that the evidence must convince the jury of the prisoner's guilt beyond a reasonable doubt.*
> *4) that unless they are satisfied that there was a conspiracy between the prisoner and Ann Melton, and that they acted in concert in the perpetration of the homicide, then nothing that she said or did, not in the presence of the prisoner, is any evidence against the prisoner.*
> *5) that if they are satisfied that there was no confederacy between the prisoner and Ann Melton, and they acted in concert in the perpetration of the homicide, then nothing done or said by Ann Melton, not in the presence of the prisoner, would be evidence against the prisoner except acts done in furtherance of the common design and declaration accompanying such acts.*

So, the first task of the jury is to decide the last two charges. The fourth charge must be considered first because if there was a conspiracy between Ann Melton and Tom Dula to commit the homicide, then most of the testimony must be considered in deciding guilt or innocence. Is there direct evidence of a conspiracy (between Tom Dula and Ann Melton) to commit the murder of Laura Foster? Pauline Foster, in the undated transcripts, said that Ann Melton wanted to kill Laura Foster, but she did not state that Ann Melton and Tom Dula planned to kill Laura Foster. Celia Anderson Scott and Pauline Foster both testified about the fight and arguments at the Scott home. Both stated that Ann said she and her "best friend" (Tom Dula) had colluded or commenced "to seek, or get their revenge." Mrs. Scott testified that Ann said that only four persons—Ann Melton, Pauline Foster, Mrs. Celia Scott and Tom Dula—knew about or heard about the incident, so that if it came out, Ann would know who and where it came from. Was that sufficient to establish a conspiracy to murder Laura Foster?

Pauline Foster also testified to several hushed conversations between Tom and Ann, but no content of those conversations was known. Since no clear evidence of a conspiracy before the fact can be established, count four of the charge must be answered with a "no proof of a conspiracy." Furthermore, the intent and meaning of getting "her revenge" on the part of Ann Melton is not established. Ann is not on trial, so her reported comments here are not relevant and must be disregarded as evidence against Tom Dula.

Moving on to the fifth charge: was there a confederacy between Ann Melton and Thomas Dula in committing the murder of Laura Foster? In other words, did they act together or in concert to murder Laura Foster? This is a separate question from "Was there a conspiracy to commit the murder?" This question addresses the act of committing the actual murder. The murder of Laura Foster, according to the prosecution and the presented evidence, took place on Friday, May 25, 1866. The exact time is not established, but the time line of events indicates two possibilities: the murder could have occurred either between 10:00 a.m. and 12:00 p.m. or later, between about 6:00 p.m. and 8:00 p.m. on that day. Ann Melton returned to her own home very early in the morning on May 25, 1866, and was known to have been there until after midnight the same day. Tom Dula is unaccounted for between mid-morning and noon and during an hour or so in the early evening of the same day. Thus, Ann and Tom could not have committed the murder *together* on that day. Ann was home and accounted for and was not with Tom at any time on the day Laura Foster disappeared. To count five, it must be answered that the evidence suggests they did not act together

to commit the actual murder of Laura Foster. Thus, any evidence of what was done or said by Ann Melton not in the presence of Tom Dula must be disregarded as evidence against the prisoner. This means, in particular, that the evidence given about the fight at the James Scott residence between Ann Melton and Pauline Foster should be given no weight in deciding the guilt or innocence of Tom Dula. With those two counts settled, the jury must move on to the other counts and the actual evidence that was presented in the case.

To prove a murder, there must be at least two items of evidence: 1) a motive to commit a murder and 2) an opportunity or occasion to carry out the murder. In a case where the evidence is circumstantial, the evidence must be very strong. The injury to Laura Foster was believed to have been inflicted by a knife wound to the left breast between the third and fourth ribs. It is not known if it pierced the heart, but a spot believed to be blood indicated massive bleeding from the wound. If the heart were struck, the death would have been instant, but if not, then the victim still would have died quickly from the blood loss. The bill of indictment stated:

> *Thomas Dula with a certain knife of the value of five cents which he the said Thomas Dula in his right hand then and there had and hold the said Laura Foster in and upon the breast of her the said Laura Foster then and there feloniously willfully and of his malice aforethought did strike, thrust and stab, giving to the said Laura Foster, then and there with the knife aforesaid in and upon her breast of her the aforesaid Laura Foster one mortal wound of the breadth of one inch and the depth of six inches of which the said mortal wound the said Laura Foster instantly died.*

Thomas Dula was known to possess what may have been the murder weapon. He carried it in a pocket made in his coat. No one, on the record, testified to witnessing the actual murder. The most that can be inferred is that Tom Dula possessed and carried what could have been the murder weapon of the appropriate size and type that could have inflicted the fatal wound. Did Tom Dula have a motive for being willing to murder Laura Foster? Rufus D. Hall testified that Tom stated to him that he was diseased and intended "to put through" the person who had given him the disease. Tom did not say who that person was. Ann Melton told Pauline, not in the presence of the prisoner, that Laura Foster had given Tom "the pox," and he, in turn, had given it to her. That statement cannot be considered as evidence. However, Tom did tell Dr. George N. Carter that Laura Foster had given him the disease. Therefore, the threat

related to Rufus D. Hall and the testimony of Dr. Carter combine to establish a motive for the murder.

Is that a sufficient motive for a murder? That question would depend on the individual and, at first consideration, strikes one as a weak motive. Are there additional factors that would enhance this motive? Pauline Foster testified that Ann Melton had great influence over Tom Dula and was known to be very jealous of his involvement with Laura Foster. She had threatened Laura herself and, according to Pauline, was furious with her for giving "the pox" to Tom and in turn to her. In addition, both Ann Melton and Tom Dula were suffering the initial stages of their venereal disease and the cost and inconvenience of having to submit to medical treatments. The combination of those factors was sufficient to induce Ann Melton to

> stir up, move, and abet, and cause, and procure the said Tom Dula to commit the said felony and murder, and him the said Tom Dula did then and there feloniously willfully and of malice aforethought receive, harbor, maintain, relieve, comfort and assist against the dignity of the State.

The combination of these events and factors is sufficient to conclude that Tom Dula did have a motive to murder Laura Foster.

Next, did Tom Dula have the opportunity to carry out the murder of Laura Foster? Testimony was given that Tom Dula came to Laura Foster's home on the morning of May 25, 1866. No one actually saw him there, but Laura Foster confided to neighbors and to Betsy Scott on the River Road that Tom had come in the morning, and they were going away together. She had also confided in a neighbor in a previous conversation on or about Wednesday, May 23, 1866, that she and Dula were planning to go away together. Testimony was also given about Tom's movements on a path leading back from Wilson Foster's house to the Reedy Branch settlements. It was established that Laura Foster was heading to the Bates Place, which was about six miles east of her home, just off the Stoney Fork Road. Witnesses testified to seeing her on her way there even if they did not speak to her. Testimony was also given that Laura was to meet Tom Dula at the Bates Place. Laura Foster had taken her father's horse, apparently to speed up her trip to her meeting place, and had taken a bundle of clothes with her. No testimony was recorded that Laura Foster was actually seen at the Bates Place after she arrived there. Of course, the Bates Place was an abandoned blacksmith shop site on a ridge off the Stoney Fork Road, and it had long since grown up in brush and trees, so it would have been easy to conceal

her presence. Did Tom Dula meet Laura Foster at the Bates Place? Several witnesses saw him going along the road that led to the Bates Place, but he also could have been going to his home. Later in the day, about dark, he was again seen going in the direction of the Bates Place. However, no recorded testimony actually placed him at or near the Bates Place.

Tom Dula's mother verified that he was not at home on the morning of May 25, 1866, but when she returned home about noon that day, he was there. She verified that he went out again that evening for about an hour or so, but she did not know where he went. He later returned, and she believed he did not go out again that night. Her daughter Eliza was also living with her, but it was not established that she was at home on Friday, May 25, and she did not testify as to Tom's whereabouts on that day. The jury must conclude that Tom could have had the opportunity to meet and murder Laura Foster either on the late morning of May 25, 1866, or at about dusk on the same day. However, the jury cannot conclude from the existing testimony that Tom Dula actually met Laura Foster at the Bates Place at any time on that day.

The jury must, therefore, look at additional testimony to examine the events of May 25, 1866. Witnesses testified that Tom Dula visited Ann Melton's mother on Thursday, May 24, 1866, and borrowed a mattock, reportedly to improve the path near his home and to "work some devilment out of himself." He did not return the mattock for some two or three days. He was later encountered on the path along the Reedy Branch, leading to his home from the Stoney Fork Road, digging at a steep area of the path. He told witnesses that he was improving the path so he could go along better at night. On the same day, he had obtained a canteen of whiskey and had met with Ann Melton at her mother's cabin at about 3:00 p.m. Both he an Ann left from there but went in opposite directions. Pauline Foster testified that Ann said they had stayed out all night, with her mother, and had drunk the canteen of whiskey. The canteen was later found where Ann said they had left it. Ann's mother, Lotty Foster, never verified that statement or her presence in any recorded testimony.

As it became generally known that Laura Foster had planned to run away with Tom Dula but Dula was still in the community, people began to suspect that something foul must have befallen Laura Foster. After Wilson Foster's mare returned to his home, and the places where it had been tethered were found in the vicinity of the Bates Place, a spot of presumed bloody earth was found that led to the suspicion that a murder must have taken place there. Since Tom Dula was believed to have met Laura Foster there, he

became the logical suspect in her disappearance. To further strengthen the circumstances, it was testified that Tom Dula never joined in or engaged in any of the searches for Laura Foster, even when the search parties were near his home.

Wilson Foster became convinced that his daughter had not run away but had been disposed of by Tom Dula, Ann Melton, Ann Pauline Dula and Granville Dula, and he swore out an arrest warrant for them. In the meantime, James Melton told Tom Dula that he was the prime murder suspect and that they were going to arrest him. Dula decided to leave the area, at least for the time being, and went to Watauga County and later over into Tennessee. The others, who were subsequently arrested, had alibis and were found not guilty and released. That made Tom the sole remaining suspect, and a warrant was issued to find and arrest him. The fact that he had fled the area strengthened the suspicions that he was somehow involved in or knew something about Laura's disappearance. Tom Dula was arrested on July 10, 1866, just over the Tennessee border, where he had been employed under the false name of Tom Hall. This implies that he was hoping to remain unidentified while at large.

Tom Dula was returned and held in jail on suspicion of committing murder until the body of Laura Foster was found, some four months after her disappearance, in a shallow grave that was dug on a ridge above the Dula home. The grave was some two hundred yards from the spot where Tom Dula had been digging on the Reedy Branch path. James Isbell testified that after Laura's body and the soil were taken out of the shallow grave, there were markings of a mattock on the side of the grave. Tom Dula had borrowed a mattock from Lotty Foster just before Laura disappeared.

The location of the grave was found after Ann Melton confided in Pauline Foster that she knew the location of Laura's grave and wanted Pauline to come with her to ensure that it was still well concealed from the continuing search parties. Pauline had made careless remarks to the Wilkes deputies that seemed to implicate her in Laura's disappearance, and they were questioning her for more details. She revealed what Ann Melton told and showed her, and that led to the search party that located the grave site.

How did Ann Melton know where the grave site was? Either she had killed and buried Laura or she knew who had done it and perhaps had assisted. The testimony about the grave site was given by Pauline Foster, and the discovery was testified to by James Isbell and others, thus these were admissible as evidence against Tom. The circumstances are that the borrowed mattock, the location of the body and the grave site, implicate Tom as well as Ann

and Pauline, but only Tom is on trial here. The conclusion is that Tom either dug the grave or assisted others in digging the grave and burying the body of Laura Foster. Ann Melton and Pauline Foster had alibis for the time when it is believed that Laura Foster was murdered. Thus, Tom Dula, who did not have a credible alibi, became the primary suspect.

Does this evidence exclude all others? Only Ann Melton knew the whereabouts of Laura Foster's grave, so either she killed Laura Foster and buried her or Tom Dula did, or they did it together. Could someone else have killed Laura Foster? If so, how would Ann Melton know the location of the grave? Pauline is the only other suspect, and she did not know where the grave was; therefore, she can be eliminated as the murderer. The jury must conclude that Tom Dula was either the murderer or he an accessory to the murder. This conclusion meets charges one and two.

What about charge three? Does the evidence convince the jury beyond a reasonable doubt? The conclusion is in two parts: 1) Is Tom Dula an accessory to murder? Yes, beyond a reasonable doubt. 2) Did Tom Dula commit the murder of Laura Foster? There is insufficient evidence to state that Tom Dula alone committed the murder of Laura Foster, beyond a reasonable doubt. The conclusion to charge three must therefore be no because of insufficient evidence. Therefore, Tom Dula could not necessarily be found guilty of the act of murder but was certainly guilty as an accessory to murder.

The evidence in this case, even though circumstantial, places the murder in the hands of Ann Melton and Thomas Dula. However, the forensic evidence is quite weak and does not identify who actually committed the murder. On the other hand, the evidence does not conclusively exclude Ann Melton for the same reasons that it does not conclusively convict Tom Dula. The evidence does lean toward Tom Dula as the murderer because he had the knife, had made threats against Laura, had the motive, had the opportunity and ran away when he became a suspect with no alibi for the time Laura was killed. Tom Dula is therefore found guilty of the murder.

Note that this conclusion does not exclude Ann Melton of the murder or of being an accessory to murder. Only Tom Dula is on trial at this time, and the jury can pass judgment on his guilt or innocence only from the evidence presented against him.

MYTHS, ERRORS AND LIES

The story of Tom Dooley and Laura Foster, as told in Western North Carolina, has many versions, most of which are without basis in fact. The ballads have given rise to many of the myths, and local folklore has added to, modified or just made up many versions of the story. Some versions seem to have been made up to deny that Tom Dula committed the murder and that Ann Melton was the actual murderer. The more common myths are discussed here.

What is commonly known as "The Legend of Tom Dooley" is a romanticized version of the story that places Tom Dula and Ann Foster as teenage lovers before the Civil War. Tom leaves Ann when the Civil War begins, and she pines for him while he is away at war. Believing that she might never see him again, she marries an older wealthy man named James Melton. When the war ends, Tom returns to find his true love has married. He takes up with her cousin Laura Foster but also rekindles his relationship with Ann, despite the fact that she is now married. The venereal disease appears, and Ann and Tom conspire to dispose of Laura, thus ridding Ann of her rival for his attentions and taking revenge on Laura for giving them the disease. They plan to rekindle their prewar relationship after Laura is out of the picture.

Some versions have Laura pregnant and pressuring Tom to commit to marriage. In other versions, Pauline, or "Perline," is also involved in the affairs and is a rival for Tom's attentions. In other variations, Ann and Pauline dispose of Laura, and Tom is involved only in helping dispose of

the body. This is some of the folklore that has given rise to fictional books, ballads and stories based loosely on the Tom Dula saga.

The folklore or myths in these versions are several. First, Ann Melton was one year older than Tom Dula, and while they may have been intimate lovers as teenagers, they had no known plans to marry. Ann married James Gabriel Melton, age twenty-one, in 1859, when she was sixteen, while Tom, at fifteen, was still at home with his widowed mother. Note that both parties (James and Ann) were of the minimum marriageable age at that time. Ann was the local beauty and probably had many suitors but chose to marry James Melton. James was neither old nor wealthy, although he may have been a better marriage prospect than the young Tom Dula. More likely, Ann married James to move into a more stable home; besides, Tom was well under the age for legal marriage. Furthermore, though not wealthy, James did have a vocation and land and was probably better off than many of his neighbors. James's property was adjacent to Ann's mother's land, and in addition to farming, he was a carpenter and wagon maker and was learning the trade of a shoe cobbler.

James left Ann four months after the birth of their daughter to enlist in the Confederate army shortly after the Civil War began. Ann had become pregnant about one year after their marriage, and they had a daughter in February 1861. It was sometime after James enlisted that Tom Dula reentered her life, and presumably they resumed their intimacy. Tom also left her after several months and joined the Confederate forces. When Tom returned from the war, at some point they again resumed their relationship. Exactly when this occurred is not known, but it was ongoing when Pauline Foster arrived in early March 1866.

Pauline Foster was never a rival of Laura Foster and Ann Melton for Tom's affections because she was his second cousin and was herself being treated for a venereal disease in order to complete her own marriage bond. She had come to Wilkes for medical treatments so she could be cured and then be married to John Scott. She only "romped" with Tom, at Ann's request, to distract her neighbors (and possibly Ann's husband) from her ongoing affair with Tom Dula.

There was no evidence that Laura Foster was pregnant or that she and Tom were "running away" to get married. They were both of marriageable age in 1866 and would not need to "run away." If they were running away, they would have gone west toward Tennessee, not east to the Bates Place. Tom had arranged to meet Laura at the Bates Place because it was an abandoned location near where he (and possibly Ann) had pre-dug a grave to bury Laura's murdered body.

Ann Melton and Pauline Foster were both at the James Melton property all day and into the late evening on the day Laura was murdered. Ann was in bed, likely "hung over" from drinking the night before, and she remained there all day and into the evening. Several persons who had attended the gathering at James Melton's house that evening verified the presence of Ann and Pauline at the cabin.

Of course, neither Ann nor Pauline was ever charged with the murder of Laura Foster. Thus, the romanticized version of the story may be popular but has little to do with the actual facts. For example, Karen Wheeling Reynolds, in her play and books, makes the legend into a fictional romantic triangle: Tom went off to war and left Ann pining for him. She marries a wealthy older man in his absence. Reynolds states herself that her fictional works are a mixture of fact and folklore from the local area.

Another such legend was told in the *Wilkes Recorder* on July 4, 2001, and suggests that a fourth person present during the fight between Ann Melton and Pauline Foster at the James Scott residence might have been James P. Scott, the son of James and Celia Scott. The paper describes an interview with an eighty-three-year-old Edith Law. She stated in the interview that in the 1940s she heard "the truth of the matter" from her now deceased neighbor, James Pinkney Scott. According to Mrs. Law, Mr. Scott told her, that he, twelve years old at the time, had been present when Pauline and Ann told his mother that they had agreed on killing Laura Foster. He said Ann had gone with Tom to meet Laura Friday morning and that Pauline had requested that Ann "do as they had planned." Ann Melton stabbed Laura Foster with a knife. According to her story, Tom Dula didn't have anything to do with the actual murder.

The newspaper article doesn't say anything about him helping her hide the body, so she claimed that he might not have done even that. If any of this were true, why was James P. Scott's testimony not taken into account during trial? If true, it could have saved Tom from the gallows and sent the two women there instead. A possible explanation was that his age might have prevented his testimony. Either Mrs. Law remembered his (Mr. Scott's) story incorrectly and claimed that James P. Scott was twelve at the time of the murder or he himself remembered his age incorrectly. All the census records, as well as the death certificate of James P. Scott, agree that he was born in 1862. The murder took place in 1866, so he could have been only three or four at the time of this incident. What he told Mrs. Law was undoubtedly not his own memories but something that he had been told or something he overheard at a later time. His story about Ann and Pauline agreeing to

murder Laura is not even consistent with his own mother's testimony during the trial. Ann, of course, was home in bed when Laura was likely killed, and Pauline was planting corn in the field all day with James Melton and Will Holder. Neither person could have been involved in the actual act of murdering Laura Foster.

This is just another example of the many hearsay myths that have accompanied the oral retelling of this story. The trial evidence all contradicts this version. This is clearly one of the many local myths that many Wilkes people still choose to believe. In truth, Ann Melton returned home early the Friday morning of Laura's disappearance and was in bed there until late in the day. She was seen there by several witnesses, as was Pauline, who was working all day with James Melton and another man. Laura was seen at this same time, miles away, on the River Road, heading to the Bates Place. At the very best, this story was just a repetition of an old story passed down by persons who knew little or nothing about the true facts of the case. Probably, Mr. Scott remembered only some of what he had overheard from his parents, and Edith Law may have added her own opinions from the many rumors she had heard in the community.

Other popular stories that were circulated about Tom Dula are that he "entertained Col. Zebulon Vance's troops around the camp fires at night, playing the banjo and singing." The problem with that story is that Tom was in the Forty-second Regiment, while Vance commanded the Twenty-sixth Regiment. Tom did not play the banjo, and his unit spent most of its time drilling and on guard duty during most of the war. He was frequently reported on "sick call" and did not know Zebulon Vance, his defense attorney before, or during the war.

One of the enduring questions in the legends of Tom Dula is how and why Zebulon Baird Vance took the case to defend Tom Dula and Ann Melton. Some writers have said that Major David Horton, a cousin of Tom's, asked Vance to defend him. Rufus Gardner, in his book *Tom Dooley: The Eternal Triangle*, says that Colonel James Horton, a cousin of Tom's, asked Vance to defend him. There are no known records to confirm or deny either claim, so one can only examine the feasibility of this story. To be even a distant cousin of Tom Dula, a Horton would have had to come from either General William Horton's family or from Major David Eagles Horton's family. These men were married to two daughters of Captain William Dula of Happy Valley and thus were distant (second) cousins of Tom Dula by marriage.

General William Horton did not have sons named David or James, so that leaves Major David Eagles Horton's family, who did have sons David L. and

James T. Horton. However, there is no record of either of these sons having a military rank of major or colonel. Major David E. Horton, their father, was with James Isbell when they found the grave of Laura Foster. James Isbell was married to Horton's daughter, Sarah Louise Horton, and therefore was a brother-in-law to David L. Horton and James T. Horton. Both of these men may have been in the large search party when the body of Laura Foster was found. Given James Isbell's apparent obsession with finding Laura's grave and his determination to convict Tom Dula and Ann Melton, it seems likely that his brothers-in-law would hold similar views. They would each have a distant (third cousin) kinship to Thomas C. Dula. Reports were that after Tom and Ann had been indicted, James (Jim) Horton visited Tom in the Old Wilkes Jail and prevailed on him to confess if he had any involvement in the disappearance of Laura Foster. Tom steadfastly and adamantly stated that he knew nothing about her disappearance and murder and refused to acknowledge any awareness of the involvement on the part of Ann Melton in Laura's disappearance. This claim was made despite the fact that Ann knew where Laura's body was buried.

"Colonel" Horton was a close friend of Zebulon B. Vance, and Vance often stayed at his home when he was visiting in the area. Jim Horton apparently believed Tom's denials and suggested to Vance that he defend Tom because he had been a loyal and dependable Confederate soldier. In addition, Vance knew James Melton as the standard-bearer of his regiment, the Twenty-sixth Confederate Infantry, when Vance was the regiment's commander. The combination of these events apparently was enough to convince Vance to undertake the defense of Tom and Ann.

It is a Melton family tradition that James Melton and the Melton family were the ones who asked Vance to defend Tom and Ann. Note that at that time, Tom Dula and Ann Melton were both scheduled to be tried together, and although Tom Dula alone was charged with the murder of Laura Foster, Ann Melton was charged as an accessory before and with harboring the murderer after the fact. Furthermore, Vance was not asked to defend Tom and Ann until after Laura's body had been found, and Ann Melton had been arrested and indicted along with him. Undoubtedly, the publicity that the case was receiving was also a factor in motivating Vance to take the case. It is presumed that he took the case pro bono since Tom had been declared indignant.

Another myth or legend from the folklore is that Tom Dula himself composed a version of what is known today as "The Ballad of Tom Dooley." The story goes that he sang his composition to the waiting crowds on his way

to the gallows while sitting on his coffin. The *New York Herald*'s comprehensive report of Tom's execution certainly doesn't mention any incident like that. Tom would have been shackled on his way to the gallows and did not likely sing or play anything. His reputation as a desperate character who had been guarded day and night in the Iredell Prison would have precluded his having his hands free, and he likely was in leg irons as well. There is no official or other record of any ballad he may have composed himself. He did address the crowd at length before his execution, and he had written a statement about his life that he gave to one of his attorneys before his trip to the gallows. However, there was no mention of any ballad or other musical composition in the *Herald* article, and there was no mention of Tom singing or playing anything on his way to the gallows.

Unlike what is claimed in several of the ballads and poems describing the Tom Dula saga, Tom was not hanged from an "old oak tree" and definitely was not hanged in a "lonesome valley." He was hanged from a makeshift gallows beside a railway station in Statesville, North Carolina. One might say he was " hanged in the public square," much like times of old. Several thousand persons attended the public hanging and heard his last remarks. It was very far from a "lonesome valley." Daniel W. Barefoot, in his book *Haints of the Hills* from 2002, tells that when Tom's body was brought back to Elkville, it was placed on his bed in the cabin on the Reedy Branch where he lived with his mother. This may very well have been partially true, as a proper grave might not yet have been prepared. Later, Barefoot continues, Tom's wounds began to bleed. This sounds not so likely, though, as he had been dead for several hours at the time. The blood on the floor was impossible to remove, according to Barefoot, and the cabin was thereafter considered haunted until it was torn down many years later. Hanging by the neck, and in Tom's case suffocating from the hangman's rope, did not result in open wounds that would have bled. It is possible that he may have bled some from his nose or mouth, but his body had been placed in the already prepared coffin that was brought to the hanging by his sister and her husband. It is unlikely that the body was removed from the coffin before the burial. It is possible that his body could have been removed from the coffin, cleaned and then redressed for burial, but no known record states that this was the case. Tom's body was buried on land belonging to his cousin Bennett J. Dula II, not far from where his home was. The gravesite is there today just across the Yadkin River near Ferguson on private property, but the headstone has been vandalized by souvenir hunters. Public access to the site is no longer available.

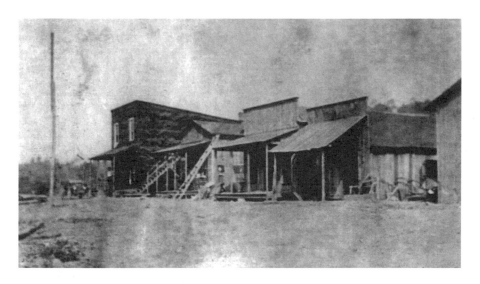

Old Ferguson, Wilkes County, North Carolina, circa 1900. *Author's collection.*

Modern-day Ferguson, Wilkes County, North Carolina, in 2012, viewed from Tom Dula Road. *Author's collection.*

Historical marker about the Tom Dula saga on Highway 268, about one and a half miles from Tom Dula's grave near Ferguson, North Carolina. *Author's collection.*

Another common misconception about the hanging is that Tom's sister Eliza and her husband, allegedly Anderson Dula, received the body after the execution. Anderson Dula was not married to Tom's sister Eliza. Eliza was never married and did not receive Tom's body after the execution. As stated previously, the persons who were present and rode to the execution with Tom and his coffin were his older sister, Anna Evaline Dula Hendricks, and her husband, Micajah C. Hendricks. Micajah was also a witness at Tom's trial, although his testimony was not recorded. Several writers have repeated this error. Tom's other sister, Sarah, was married to a William Fletcher and lived in Boone, Watauga County, and she did not attend the trials or the execution. Anna had to be the sister who attended the execution.

Another popular myth that seems to have no real origin or facts to support it is the story of Bob Cummings. He is mentioned both in John Foster West's first book and in Karen Wheeling Reynolds's books and the play *Tom Dooley, a Wilkes County Legend*. The story goes that Bob Cummings was a Yankee schoolteacher who was a suitor of and was in love with Laura Foster. He is also mentioned as "Bob Grayson" in Doc Watson's version of

the saga. Watson claims that his grandmother told the story to him. Watson's grandmother, Betty Triplett Watson, supposedly knew Ann Melton and was present in the room when she died.

The story claims that Bob Cummings joined the posse and helped track down Tom Dula when he was heading for Tennessee. The lovesick Yankee teacher captured Tom before he could get out of the state and helped return him to Wilkes for trial. The truth is that there is no record that a Bob Cummings ever existed. The schools were all closed during the Civil War, and there were no Yankee schoolteachers in the system before or during the war. Besides, Laura would have been only about fourteen or fifteen years old when the schools were closed and not likely attending school during those years. Bob Cummings was not listed among any witness lists, census records or tax records for this time period. He was not mentioned as a member of any search party and was not a member of any Wilkes posse stalking Tom Dula. Tom was captured in Pandora, Tennessee, after he left the state of North Carolina. One can only conclude that this story is complete fiction and, again, was made up by the local people who have romanticized the true legend. This story is also sometimes referred to as "The Legend of Tom Dooley," particularly in connection with the development of the "Ballads of Tom Dooley."

Other writers have repeated a similar story but used the name Bob Grayson for Laura's alleged lover. In this case, the writers have mixed the folklore with the name of the man who actually helped capture Tom Dula in Tennessee. He was Lieutenant Colonel James W.M. Grayson, but he never knew Laura Foster, and he lived in Trade, Tennessee. He was not a schoolteacher and was not otherwise involved in the saga. One such version is repeated in the Wilkes County Heritage Book but unfortunately is almost entirely folklore. The story was written by Nancy Alexander but contains very few of the actual facts of the case.

John Foster West describes a story told to him in an interview with one Wade Gilbert in July 1969, when Gilbert was eighty-one years old. Matthew Wade Gilbert was the illegitimate son of Ellen Gilbert, who was herself the illegitimate daughter of Louisa Gilbert, James Melton's second wife. He claimed to have "inside information" on the "true story" of what actually happened. He did not explain how his grandmother would have better information than anyone else since she did not attend the trials and was not, at the time, involved in any of the events of the Tom Dula saga. James Melton did not discuss the Tom Dula affair and was always defensive of his wife, even after she died. His Melton children and relatives also did

not discuss the events of the trials or Ann's involvement. They extended that policy even to their own children. For example, Edith Melton wrote a history of the Melton family and did not even mention Anne Foster's name as James's first wife. The story, as related by Wade Gilbert to Professor West, was the following:

Tom Dooley told Laurie Foster he would marry her. Laurie got on her daddy's horse and rode down the road to a place where she was killed. She met an old woman who had been a slave named Aunt Appline at Elk Creek and told her where she was going. Ann Melton and Pawline Foster, her sister, held Laurie Foster, and Tom Dula stabbed her. They carried her body wrapped in a sheet and tied to a pole held between them down the ridge and buried her at night. They had to break her legs to fit her into the short grave.

Old man Foster's horse was gone several days. One day he found it eating in a field. It had been tied to a tree close to where Laurie was killed and broke loose. They found the tree where it had been tied near where the place Laurie was killed, Tom Dooley was eating dinner [lunch] at Rufus and Nancy Hall's house, and Rufus went outside in the yard with Tom. Tom said, "If I live, I'll kill the woman who gave me the disease, if it's the last thing I do on earth." Laurie Foster was a nice woman. I never heard nothing against her.

When that old Pawline Foster saw she was in trouble, she turned state's evidence against Tom and Ann Melton. Her mother rode a horse down the river road to Wilkesboro and raced with old man Foster to see who would get there first to turn state's evidence. Pawline's mother won. Grayson caught Tom Dula over in Tennessee, and he was brought back to stand trial.

Old Lott Foster, Ann Melton's mother, would get down in the floor dead drunk. Ann Melton would lay with just about anybody that come along. Sometimes she would do it [have sex] with haulers who camped with their wagons not too far from her home for tobacco, cloth or anything they had. She would lock her younguns up in the house by theirselves and leave them all night. She had two girls, but I don't know when they borned. One was named Jane and the other one Ida. Ida moved away to Caldwell [County], and I don't know what became of her. Jane married a good man and had nine children. They were good, decent folks. After Ann Melton died, my grandmother, Louisa Gilbert, married James Melton. He was a good man.

There are many errors and misconceptions in his story. There was no evidence that Tom Dula ever told Laura Foster he would marry her. The

person Laura met on the River Road was Betsy Scott, not an ex-slave. Possibly she also met Angeline Scott, another ex-slave, on that same road. Angeline Scott was in a witness list, but she was never recorded in any testimony. Laura had discussed running away with Tom Dula with Betty Scott, a neighbor, who lived near the River Road. Whether she met another ex-slave at Elk Creek on her way to the Bates Place never came up in any recorded testimony. Pauline Foster was not Ann's sister. Wade Gilbert should have known that. She is believed to have been her fourth cousin. She could not have held Laura for Ann to stab because both she and Ann were at James Melton's home the entire day, evening and night on the day Laura was murdered. They could not have carried the body anywhere and buried it for the same reasons. Laura's legs were not broken but were drawn up into the fetal position. No witness, and certainly not Dr. Carter, ever claimed Laura's legs were broken. Wilson Foster's mare had returned to his home by the Saturday morning after Laura disappeared. It was not found eating in a field unless that field was at Wilson Foster's home. Laura Foster may have been a "nice" woman, but she was also known to be "frail of moral character" and had "round heels," meaning she was quite promiscuous. Her own father had testified to that.

Pauline's mother was never in Wilkes or Iredell during the trials and had nothing to do with any of the testimony. Why would she race old man Foster to turn state's evidence? That part of his story is purely folklore. Ann did have two children, but only one was born before the murder trials, so "her girls would not have been locked up while she lay with haulers" during the war. Ida was born in February 1871 and was raised by his grandmother Louisa Gilbert Melton. Wade Gilbert should have known that. The rest of the comments about Carlotta Foster and Ann Foster appear to be local gossip thrown in for good measure. Those rumors may have had some truth to them inasmuch as James Isbell, in his testimony, attempted to insert into the record that Ann had illicit relations with more men than just Tom Dula. However, he admitted that he "had no use for the defendants" and was just "interested in the good of the community." He had personally led many of the searches for Laura's body and had funded the prosecution in order to help get Tom and Ann convicted. Some of his testimony was hearsay evidence that was not verified by any other testimony. He had also perjured himself in his testimony when he said "no one else had run off from the community" after Laura disappeared. In fact, more than one other male suspect had made himself scarce after Laura's disappearance.

Matthew Wade Gilbert was born in about 1888, some twenty years after the final Dula trial and well after Ann Melton and Carlotta Triplett Foster

had both died. His grandmother Louisa married James G. Melton in 1875, thirteen years before he was born. Wade would have had no firsthand knowledge of the events of the legend. He was himself an illegitimate son of Louisa's daughter Ellen Gilbert, who had two illegitimate children and was never married. The rumors about Ann Melton and Carlotta Foster may have just been jealous stories he heard from his grandmother to distract from her and her own daughter's indiscretions. In any event, it is clear that his story has little or no truth, or any resemblance to the known facts.

Another common myth is that Ann Melton had lain in wait for Laura Foster to meet Tom Dula at the Bates Place, and when Laura and Tom met, they both mounted Laura Foster's father's horse and began to ride away. At that time, Ann Melton stepped out from behind a tree and stabbed Laura Foster. First of all, a person sitting on a horse is about eight to ten feet above the ground. Laura Foster was stabbed high in the left chest between her third and fourth ribs, just above the heart. It would be physically impossible for anyone, let alone a woman between five and six feet tall, to stab someone on a horse in the chest while standing on the ground. She also could not have jumped high enough to stab Laura in the chest.

Besides, the horse would have bolted if someone had jumped out from behind a tree and confronted Laura and Tom. Of course, she could have pulled Laura off the horse and then stabbed her, but it is known that Ann was nowhere near the Bates Place when Laura was likely murdered. Again, this is another of the folklore stories that have circulated throughout Wilkes following the murder and trials.

Other fictional approaches to the story make Pauline Foster the villain, with her inciting Ann and Tom to kill Laura as revenge for their treatment of her during the summer of 1866. Such stories loosely follow some facts of the case but weave fictional tales that are not intended to be historically correct. Pauline Foster was actually a former resident of Caldwell County and had lived at Kings Creek with her family. Her father was Levi Leander Foster, who was married to the widow Anna Church Hughes. Levi was the illegitimate son of John "Jack" Dula of Kings Creek, and his mother was a daughter of Robert Foster, an uncle of Carlotta Foster and Wilson Foster. Pauline's family was actually known as Dulas rather than Fosters when they lived in Caldwell during the early 1860s. Her last name, Dula at that time, led to Wilson Foster's confusion when he swore out the warrant for the arrest of the persons whom he suspected of being involved in Laura's disappearance. The Levi Foster (Dula) family lived near the Wilson Fosters at that time, and that could explain how Laura Foster knew Pauline and why she visited her

when she first came to Wilkes for medical treatments. She was also related to both Laura Foster and Ann Foster as a fourth cousin.

Pauline Foster may have been a somewhat innocent and naïve young woman who became inadvertently involved in Ann Melton's manipulation of the principals in the Tom Dula saga. Pauline was aware of Ann's animosity toward her first cousin Laura Foster, who was also Pauline's fourth cousin and was well acquainted with her. She became aware of Ann and Tom's plans to extract their revenge on Laura for giving them "the pox," but it seems clear that she did not actively participate in the plans. However, she could have been charged with being "an accessory before the fact" and possibly for "obstruction of justice" for not revealing to or warning Laura and the authorities of Tom and Ann's plans to harm Laura Foster. Clearly, she was intimidated by Ann, as was almost everyone in this story, but she seems more simple and naïve about life and appears to have resorted to heavy drinking after the murder became known to her.

While Pauline appears to have been promiscuous, she was planning her own wedding during this affair and was seeking medical treatments so that she could complete those plans. She did just that by about 1868, the time of the second trial. Pauline married John Scott about 1867 and by the time of the second trial had given birth to a son. The *New York Herald* reporter described her as "depraved," as exemplified by the fact that "she had married a white man, but bore a Negro child." That statement expresses more his racist views than Pauline's depravity. The truth is that she may have married a mulatto man who appeared to the reporter as a white man. John Scott was listed as a white man in his later census and mortality records. He may have been a member of a large mulatto family who worked on her grandfather's farm in Kings Creek. Apparently, their son, born about 1868, appeared more African American than Caucasian and thus was labeled by the reporter as a Negro. It is not likely that the reporter ever interviewed Pauline. She was clearly loose-tongued, careless in her comments and not of high moral character, but she respected the sworn oaths and, as others testified, was extremely consistent in her testimony. She was not an accomplice nor had any complicity in the actual murder.

Others have tried to identify Pauline as the source of the venereal disease. However, a careful construction of a time line of the infections suggests that Laura was already infected when she began her affair with Tom Dula and was most likely the source of Tom and Ann's infection. Pauline swore under oath that she did not engage in relations with Tom and Washington Anderson or with Ann's brother Thomas. Thomas Foster did not refute her testimony,

and neither did Anderson. That seems to support the conclusion that the infection came from Laura Foster. If her other testimony is to believed, why would she lie about just that part of her testimony? Pauline may not have been a charming, likeable person, but she was not the depraved villain others have tried to make her out to be.

One of the most maligned and perhaps most misrepresented person in the story of Tom Dooley is Ann Melton's mother, Carlotta "Lotty" Foster. John Foster West wrote in his book *The Ballad of Tom Dooley* that she was a depraved, drunken and illiterate person who gave birth to a large number of illegitimate children. From his first book, there is no document or record cited to indicate the truth of that description or any supporting documents. It is assumed, as he stated, that this characterization of her was from comments of older surviving members of the Elkville community who were quoting remembrances of people contemporary with the trial period (1860–70). Most other writers have taken that description and included it in their stories. Unfortunately, not very much is known about Carlotta and her role in the events of 1860 to 1870. Her death date is not known, and it is presumed that she must have spent her final years with one or more of her children. Records of her later children, after Pinkney Andrew, Angeline Pauline and Thomas, have not been found.

Carlotta Foster was the daughter of Thomas Bell Foster and Frances Triplett. Most stories have claimed that her children were illegitimate but do not explain how she was known as Carlotta "Lotty" Triplett in some records and as Lotty Foster in other records. Myths and rumors that circulate have claimed that she married a Triplett man or a Foster man and she may have killed him. Others have written that she merely took her mother's maiden name to cover the fact that she was unmarried and was bearing children. None of these stories was completely true. Carlotta Foster married a man named Francis Triplett in about 1840. He was the son of Martin Triplett and Nancey Brown. In the 1850 census, she was living with her mother-in-law's family, James Brown Jr. and his wife, Nancey (Brookshire) Brown. The Browns were in their seventies in 1850, so she was likely the caregiver in addition to caring for her three legitimate children, Pinkney Andrew, Angeline Pauline and Thomas Triplett. Her husband was not listed in this household in 1850. What happened to Carlotta's husband is unknown, and the rumors that she became an alcoholic and engaged in prostitution during the Civil War years may have some validity because she was apparently abandoned by him with her three small children sometime about 1858, after which she changed all their surnames from Triplett to Foster, her maiden

name. It was customary at that time for illegitimate children to take the surname of their mother. That could explain why most writers thought all her children were illegitimate. Exactly what happened to her during that time remains unknown.

Other misconceptions are that the Happy Valley residents had little or nothing to do with the Hill Country residents. That may have been partially true before the Civil War, even though many, if not most, of the landholders were related to one another. During the Civil War, the sons of all the families had lived, associated with and fought together during the war. After Emancipation, the valley plantations lost all their slaves and thus had to replace them with sharecroppers and tenant farmers. The only source of that labor was the freedmen and the Hill Country residents. That fact alone led to more direct interaction. An example of this interaction was the Melton brothers, James and Francis, who after the events of 1866 to the mid-1870s, moved from the Reedy Branch settlements to the Yadkin Valley plantations. Francis Melton lived on the plantation of Mirah Ernest, a granddaughter of Captain William Dula, and he and his family attended the same church as Dr. George N. Carter, Catlett Jones, Welbourne German and the other wealthy Happy Valley landowners. In fact, the Francis Melton

Mirah's Chapel, the Caldwell County Church attended by the Jones, Carters, Meltons and other wealthy landowners in the Yadkin Valley. It is off Grandin Road just across the Yadkin River, off Highway 268. *Author's collection.*

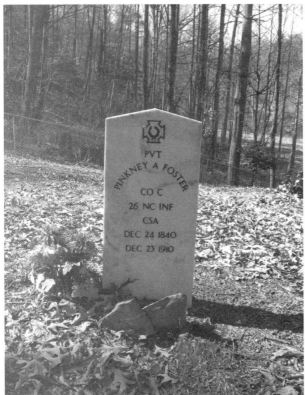

Above: Pinkney A. Foster and his wife, Lucinda Walsh Dula Foster, in their later years. *Courtesy of Tony Foster.*

Left: Confederate grave marker of Pinkney A. Foster in the Allen/Johnston Cemetery just off Gladys Fork Road near the Bates Place. *Author's collection.*

family members were instrumental in supporting Robert L. Isbell, a son of James Isbell, to become a minister. They are all buried alongside one another in the cemetery at Mirah's Chapel on Grandin Road in Caldwell County, just across the Yadkin River near Route 268.

Another example is James Isbell's efforts on the part of Wilson Foster to find his daughter's body and to prosecute her killer. Wilson farmed on his land and was a friend of Isbell. James Melton also moved to the Yadkin Valley and was farming there until his death after 1910. James Melton's second wife was Louisa Gilbert, the niece of Rufus Dula Hall, who was married to Louisa Gilbert's aunt. Louisa was living with the Rufus D. Hall family on their plantation just across the Yadkin River from Cowel's Store at Elkville. She and James were married in her uncle's home. So, the notion that these communities, especially after the Civil War, were "separate and distinct" just simply wasn't true.

In a final bit of irony, the connections between the Foster/Melton families and the Tom Dula family did not end with the execution of Tom Dula. Ann Melton's older brother, Pinkney Andrew Foster, married the widow of Tom's older brother William L. Dula, Lucinda C. Walsh Dula, in 1870. He raised William's son, Rufus P. Dula, as his own, and the couple had four additional children of their own. Pinkney and Lucinda lived in a home very near the Bates Place, and they are buried in the Allen/Johnston Cemetery, just below the ridge where the murder of Laura Foster took place. Furthermore, several of the Allen family members, the great-great-grandchildren of Ann Melton, now own much of the land near where the Bates Place was located.

Chapter 8

THE BALLADS

Most people in the United States and Canada, as well as many in Western Europe, are familiar with the "The Ballad of Tom Dooley." That awareness is mostly the result of the Kingston Trio's version of "The Ballad of Tom Dooley," which was the top song on the music charts in 1958. Many will know the chorus of the Kingston Trio's version of the song:

> *Hang down your head, Tom Dooley*
> *Hang down your head and cry;*
> *Hang down your head, Tom Dooley,*
> *Poor boy you're bound to die.*

The interest here in the ballads is twofold: the first is the origin and evolution of the various versions of the ballads and the second is the impact and influence of the song on the music industry and the development of folk as a major part of American music. This second facet of the ballads' popularity took place about ninety years after the occurrence of the original incident on which the song is based.

EARLY VERSIONS AND THEIR EVOLUTION

As to the origins of the various ballads, it is not known with certainty who wrote the first version of the lyrics and exactly when they were first written or sung. However, it is known that local poets and balladeers were constructing lyrics during and after the first Tom Dula trial took place.

By 1867, Thomas C. Land wrote a poem about the first trial and Tom's conviction. Thomas Land was a local schoolteacher and former officer in the Confederate army. He was born in 1828 and remained unmarried during his life. He knew the Meltons and was a witness to the event when Pauline Foster left the Meltons' home in Wilkes and returned to her home in Watauga County. This occurred shortly after Tom Dula had been arrested and returned to Wilkes and was being held in the Wilkesboro jail. The following is from John Crouch's *Historical Sketches of Wilkes County*:

> *Thomas C. Land is one of the landmarks of the County. He was born March 18, 1828, and was raised on a farm, attending the old field schools a few weeks for a part of the winters. He attended old Beaver Creek Academy for a short time while High Stokes was principal.*
>
> *At the outbreak of the war he joined Col. Sidney Stokes Company as a private and served during the war. He was appointed commissary and later corporal. In the Seven Days Fight around Richmond he was wounded and was allowed to come home on furlough. During his absence from the Army, he was appointed Lieutenant-Colonel of the 53rd Regiment, which position he assumed on his return to the army. He was wounded at the battle of Winchester and a number of other times but not seriously.*
>
> *After the war Col. Land returned to Wilkes and engaged in teaching school and farming. In 1870 he went to Oregon and took up land and lived there until 1884 when he returned to Wilkes. In 1891 he again went to Oregon and lived there until 1898 when he returned to Wilkes and where he has lived since. While in the West he engaged in farming, teaching and mining. Col. Land has considered literary talent and is the author of the popular ballad, "The Death of Laura Foster." It and a number of poems.*

Land's poem, entitled "The Death of Laura Foster," was intended to be read rather than being sung. The poem does not mention Tom or Ann by name in the eighty-four rather plodding lines he composed, and his effort bears no resemblance to the Tom Dooley ballad as it is known today. But he

is clear that Laura was murdered by the lover she'd hoped to go away with and that this man did not act alone:

> *'Ere sun declined toward the west,*
> *She met her groom and his vile guest,*
> *In forest wild, they three retreat,*
> *And hope for parson there to meet.*

The local audiences who first read Land's verses would have known full well that Tom Dula was the groom he had in mind and been equally sure that his "vile guest" must be Ann Melton. Throughout the poem, Land describes the pair as acting together in Laura's murder and disposal, using plural phrases like "*those* who did poor Laura kill," "*they* her conceal" and "to dig the grave *they* now proceed." By doing this, he ensures that Ann Melton is thoroughly implicated in the whole sordid affair. Laura Foster is, herself, depicted as a sweet, innocent girl, too full of childlike love to imagine Tom could ever wish her harm:

> *Her youthful heart no sorrow knew,*
> *She fancied all mankind were true,*
> *And thus she gaily passed along,*
> *Humming at times a favourite song.*

Happy Valley residents of Wilkes would have known that the real Laura was a good deal raunchier than that but swallowed the poetic license for the extra-narrative satisfaction it offered. The more of a saint Laura could appear, the more villainous Tom and Ann would look by comparison, and that's what delivered the story's disreputable thrill. Land takes us—somewhat laboriously—through the various stages of Laura's discovery and then closes with a bit of tidy alliteration and one last pious thought to ensure we don't have nightmares:

> *The jury made the verdict plain,*
> *Which was, poor Laura had been slain,*
> *Some ruthless fiend had struck the blow,*
> *Which laid poor luckless Laura low.*
>
> *Then in a church yard her they lay*
> *No more to rise till Judgement Day,*

Then, robed in white, we trust she'll rise,
To meet her Saviour in the skies.

Land wrote the poem to be read, rather than sung; however, there is one known musical setting of it. This version appears on Sheila Clark's 1986 album *The Legend of Tom Dula and Other Folk Ballads*, where Clarke gives a lovely a capella rendition of Land's full twenty-one verses, with nothing but a short fiddle phrase to divide each of its three sections. She negotiates the more awkward lines with admirable style, and it's a tribute to the sweetness of her voice that the track's nine minutes and fifteen seconds pass so pleasantly.

At some point, and perhaps at the same time, other lyrics were being sung in local gatherings by local musicians who had set some of the poems to music, perhaps adding their own lyrics or modifying existing ones to simplify or make the accounts easier to play and sing. The popularity of the ballads stemmed from the familiarity of the events to the local residents and the sensationalism that had accompanied the nation's first nationally publicized crime of passion. The fact that the trials dragged on for over two years and eventually resulted in the hanging of Tom Dula added to the popularity of the songs. The evolution of the poems and ballads were extensively discussed in John Foster West's first book, *The Ballad of Tom Dooley*, and has been further discussed in Paul Slade's Internet article "Infectious: Tom Dooley" and Peter J. Curry's Internet article "Tom Dooley: The Ballad that Started the Folk Boom." Excerpts from those articles are cited above, as are the following descriptions of versions of the Ballad.

Frank Brown's collection of North Carolina folklore, gathered between 1912 and 1943, includes three versions of "The Ballad of Tom Dooley," contributed by a woman called Maude Sutton of Lenoir in Caldwell County. Land's ballad (or poem) is the first one Sutton discusses in her letter, but it's her second entry that is of interest here. "It was very popular in the hills of Wilkes [Watauga], Alexander and Caldwell Counties in 1867," she says. "Many mountain ballad singers still sing it." Sutton then quotes three verses from the song she'd just described, which were evidently sung to the same tune that is known today:

Hang down your head Tom Dula,
Hang down your head and cry,
You killed poor Laura Foster,
And now you're bound to die.

You met her on the hilltop,
As God Almighty knows,
You met her on the hilltop,
And there you hid her clothes.

You met her on the hilltop,
You said she'd be your wife,
You met her on the hilltop,
And there you took her life.

Sutton had collected this version from a Lenoir man named Calvin Triplett. Calvin L. Triplett was born on July 12, 1848, and lived in Buffalo, Caldwell County, which was very near Laura Foster's home in German's Hill. He married Julia Cornelia Nelson in Caldwell about 1868 and in 1870 and 1880 was living in Patterson, Caldwell County, where census records list him as a farmer. By 1900, he had moved to Lenoir in Caldwell County, where he was now chief of Police and where, presumably, Maude Sutton encountered him. He died there on April 19, 1932. It's also unclear whether Sutton's three verses make up the whole song as she found it or just the first half. The 1867 verses she quotes, though, still survive almost untouched in many modern readings of the song. The Carolina Chocolate Drops, for example, open their 2006 recording of Tom Dula with these twelve lines:

Hang your head Tom Dooley,
Hang your head and cry,
Killed poor Laura Foster,
And now he's bound to die.

You took her on the hillside,
Where you begged to be excused,
You took her on the hillside,
Where you hid her clothes and shoes.

You took her on the hillside,
For to make her your wife,
You took her on the hillside,
And there you took her life.

Sutton seems to have seen this coming. "The story is just the kind to be written in a ballad and sung for generations," she wrote in her letter to Brown. "It has all the ballad essentials: a mystery death, an eternal triangle and a lover with courage enough to die for his lady."

The third ballad she contributes is the one that folklore insists Dula composed himself and sang to the waiting crowds on his way to the gallows. The *New York Herald*'s comprehensive report of Tom's execution certainly doesn't mention any incident like that. Tom would have been shackled on his way to the gallows and did not likely sing or play anything. His reputation as a desperate character who had been guarded day and night in the Iredell prison would have precluded his having his hands free, and he likely was in leg irons as well. There is no official or other record of any ballad he may have composed himself. Sutton's third ballad also opens by giving Tom an instrument (the banjo) that no one in any historical or other record ever mentions him playing.

> *I pick my banjo now,*
> *I pick it on my knee,*
> *This time tomorrow night,*
> *It'll be no use to me.*

The remaining five verses, all supposedly narrated by Tom (or someone) in the first person, tell us that the banjo helped him pass his time in jail, that Laura used to enjoy hearing him play it and that he was too much of a fool to realize how much she loved him. It's only the opening verse that still survives today, though, sometimes with the instrument corrected to become a fiddle before it's allowed a place in the main ballad. Banjo or fiddle, the sentiment remains constant, as in this verse from the Elkville String Band's 2003 recording:

> *You can take down my old fiddle boys,*
> *And play it all you please,*
> *For at this time tomorrow,*
> *It'll be of no use to me.*

By 1867, following the end of the first trial, much of the ballad that is known today was already in place among the balladeers. The chorus the Kingston Trio made famous was already 90 percent complete, and at least one of the three verses was substantially finished, too. As Tom waited in the Statesville jail

for news of his first appeal, the balladeers were still at work, and it wouldn't be long before they had the song's remaining elements in place.

In the documentary *Appalachian Journey* (1991), folklorist Alan Lomax describes Frank Proffitt as the "original source" for the song as later recorded by the Kingston Trio. Although there is at least one earlier known recording by Grayson and Whitter, made in 1929, approximately ten years before Frank Proffitt cut his own recording, the Kingston Trio took their version from Frank Warner's singing. Warner had learned the song from Proffitt, who learned it from his aunt Nancy Prather, whose parents had known both Laura Foster and Tom Dula (see Anne Warner, *Traditional American Folk Songs*) and who had the song as part of their cultural heritage.

Nancy Prather was born Nancy A. Proffitt on May 15, 1866, the daughter of John Proffitt and Phoebe Emaline Proffitt, who lived in Johnson County, Tennessee. It is unlikely that her parents actually knew Laura Foster and Tom Dula personally because they never lived in Wilkes County, but they could have known the story because they lived in Cove Creek of Watauga County in the 1880s. The Proffitt family were musicians in the local area of Watauga and Wilkes Counties and likely knew and sang the local ballads about the legend of Tom Dooley. They may have been related to Frank Proffitt, who also claimed connections to the origins of the song. The man named Grayson mentioned in the song as pivotal in Dula's downfall has sometimes (incorrectly) been characterized as a romantic rival of Dula's or a vengeful sheriff who captured him and presided over his hanging. Some variant lyrics of the song portray Grayson in that light, and the spoken introduction to the Kingston Trio version did the same. Lieutenant Colonel James W.M. Grayson was actually a Union army officer and Tennessee politician who had hired Dula on his farm when the young man fled North Carolina under suspicion of murder and was using a false name. Grayson did help the Wilkes County posse capture Dula and was directly involved in returning him to North Carolina, but otherwise, he played no role in the case.

THE MODERN BALLADS

The Kingston Trio's 1958 recording of Tom Dooley scored a top five hit on both sides of the Atlantic and dragged the burgeoning folk revival from a few Greenwich Village cafés to the global stage. It's a sparse sixteen lines long—just eighty-two words in all—and the sheer economy this forces on its

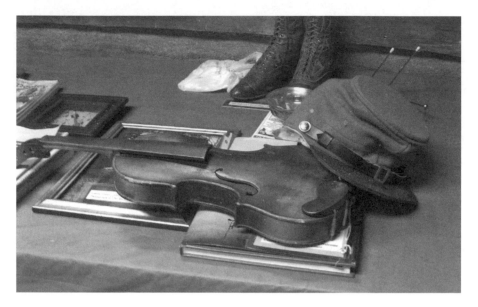

A fiddle and Confederate cap on display at the Tom Dula Museum. *Courtesy of WV/TDM.*

bare-bones tale guarantees that the record will raise many more questions than it answers. This second facet of the Tom Dooley ballads was discussed at length in Peter J. Curry's Internet article "Tom Dooley: The Ballad that Started the Folk Boom," which was written in 1998 and describes the development of the Kingston Trio's version of the ballad. The following discussions are taken from that article.

The Kingston Trio's version of the ballad was a multi-format hit, reaching number one in Billboard and the Billboard R&B listing and appearing in the Cashbox country music top twenty. The song was selected as one of the Songs of the Century by the Recording Industry Association of America (RIAA), the National Endowment for the Arts and Scholastic, Inc. That recording of Tom Dooley, which topped the music industry charts in 1958 and reportedly sold in excess of six million copies, is credited with starting the folk boom of the late 1950s and early 1960s and generating a worldwide interest in American roots music that continues to this day. That song (and the other Kingston Trio hits that followed) revived a slumping recording and musical instrument industry, created a demand for $33^{1}/_{3}$ rpm long-playing records and phonographs that could play them and, most importantly, paved the way for countless singer-songwriters such as Bob Dylan, who found in this basically do-it-yourself music an antidote to the commercialism that pervaded not only the recording industry of the day but also Western society at large.

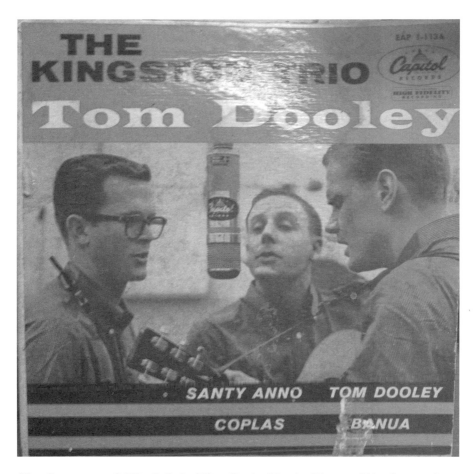

The album cover of "The Ballad of Tom Dooley," by the Kingston Trio. *Courtesy of WV/TDM.*

In light of the many trends this one song set in motion, a claim can be made that the Kingston Trio's "The Ballad of Tom Dooley" is one of the most important recordings of the twentieth century, second only perhaps to Mamie Smith's 1920 "Crazy Blues" (which was the first hit "race" recording and as such ushered in the black influence on American popular music, without which there would be no blues, jazz, swing, rock-and-roll, soul, disco or rap). Given the song's seminal role in the history of popular music, a question arises about where the Kingston Trio might have learned it. The label on the Kingston Trio LP on which the song first appeared says "Tom Dooley" was "Traditional, arranged by Dave Guard," while the LP's liner notes simply refer to it as "a classic 'do' of the Tennessee hill-folk." So

neither of these was much help in identifying the Kingston Trio's source for the song.

A subsequent legal battle resulted in copyrights being assigned to Frank Warner, who collected the song, and to John and Alan Lomax, who published it. But as was discovered, this, too, was by no means the last word on the subject of where the Kingston Trio learned "Tom Dooley" (or, for that matter, on where in fact the copyrights truly belonged). Likewise, the various published accounts of where the Kingston Trio learned the song proved less than reliable.

One of the most widely circulated accounts of the Tom Dooley–Laura Foster tragedy is the one that appeared in John A. and Alan Lomax's 1947 book, *Folk Song: USA*, which was purchased by thousands of schools and libraries across the country and remains a standard text in the industry. According to Alan Lomax, Tom Dula (Dooley's real name) fought in the Civil War with Zebulon Vance's cavalry, had seen Gettysburg and finally made it home to the North Carolina mountains only to find that his girlfriend had been seeing several other men in his absence, one of whom was a "dad-burned Yankee school teacher." It's a good folklore story, but as was shown in the earlier chapters, almost all of it is legend and totally false. Thus, as is mentioned in the Kingston Trio's spoken introduction to "Tom Dooley," there was an "eternal triangle" at play, but the participants were two women and one man. None of the principals involved was a schoolteacher, Yankee or otherwise. The only known area schoolteacher was Thomas C. Land, who wrote the first ballad poem entitled "The Death of Laura Foster."

One fiddler who could play "Tom Dooley" well was G.B. Grayson. Gilliam Banmon Grayson was born in Ashe County, North Carolina, on November 11, 1887. When he was two years old, his family moved a few miles west, into Johnson County, Tennessee, where he remained for the rest of his life. G.B. Grayson learned "Tom Dooley" from the singing of his family and had a personal connection with it. He was the nephew of Lieutenant Colonel James W.M. Grayson, who had helped capture Tom Dula in Tennessee. Nearly blind since early childhood and unable to make a living as a farmer, store clerk or millworker, Grayson made music instead. He played his fiddle and sang his songs at schools, turkey shoots, country stores—wherever he could earn enough money to feed his family. Over time, he played with most of the prominent musicians in the area, including North Carolina's Doc Walsh and Clarence "Tom" Ashley.

In 1927, at a fiddler's convention in Mountain City, Tennessee, Grayson met guitar and harmonica player Henry Whitter. Whitter, a mill hand from

Fries, Virginia, had already made some recordings as a soloist, including "Wreck of the Old 97" for Okeh Records in 1924 (which Vernon Dalhart later recorded and coupled with "The Prisoner's Song" to create the first million-selling country music hit). But they liked the way they sounded together. The crowd liked the way they sounded together. And one of the most important teams in early country and bluegrass music was formed.

Grayson and Whitter became well known locally and were soon discovered by talent scout and recording company executive Ralph Peer, who also discovered country music legends Jimmie Rodgers and the Carter Family. They recorded some fifty songs for the Peer on the Victor label between 1927 and 1929, many of which would become country and bluegrass music standards.

At a 1929 session for Peer in Memphis, the pair recorded "Tom Dooley," which sold roughly four thousand copies throughout the South and did much to keep "The Legend of Tom Dula (Dooley)" alive. Grayson was killed in a road accident in 1930, not long after his recording debut. Henry Whitter continued to make music after Grayson's death— but he was plagued with poor health and died in the State Hospital in Morganton, North Carolina, in 1940.

In 1938, folklorists Anne and Frank Warner were song hunting in the mountains of Watauga County, North Carolina. While there, they met singer and guitar and banjo player Frank Proffitt, who lived in Pick Britches Valley and was born in Laurel Bloomery, Tennessee, on June 1, 1913. "Tom Dooley" was one of the first songs Proffitt sang for the Warners. He told them it was the first song he remembered hearing his father pick on the banjo. Like G.B. Grayson, Proffitt had a personal connection to the song. He told the Warners that his grandmother, Adeline Perdue, had lived in Wilkes County and had known both Tom Dula and Laura Foster. (Note: Adeline Perdue is not listed in any 1860 to 1880 records in Wilkes County, North Carolina. Whether she was actually there at the time of the trials or had any connection to the affair is unknown.)

However far back the song went in Proffitt's family, it was new to the Warners, who apparently were unaware of Grayson and Whitter's 1929 recording on Victor. Two years later, with a newly acquired Wilcox Gay Recordio disk-cutting machine in tow, they returned to Watauga County, North Carolina, and recorded a number of Frank Proffitt's songs, including "Tom Dooley."

In a document titled "Statement of Frank W. Warner Regarding the Song 'Tom Dooley'" dated February 23, 1962, and on file in the Anne and

Ann Warner recording Frank Triplett at his home in North Carolina. *Photo by Frank Warner and Courtesy of the Library of Congress.*

Frank Warner Collection at Duke University, Frank Warner describes that recording session as follows:

> *This time* [1940] *we took down the songs in shorthand and recorded on discs several stanzas of each song to secure the melodies. On the occasion of this visit Frank Proffitt recorded for us three stanzas of "Tom Dooley." After recording this much of the song, he sang the entire song for Mrs. Warner to take down in shorthand.*

Warner then includes the following text of the song:

"Tom Dooley" (as dictated to Ann Warner by Frank Proffitt in 1940)

Hang down your head, Tom Dooley
Hang down your head and cry;
You've killed poor Laurie Foster
And for that you're bound to die.

You met her on the hillside
And there you took her life
You met her on the hillside
And stabbed her with your knife.
(CHORUS)
Hang down your head, Tom Dooley
Hang down your head and cry;
Hang down your head, Tom Dooley,
Poor boy you're bound to die.

This time tomorrow,
Reckon where I'll be—
Down in some lonesome valley
Hanging on a white oak tree. (CHO.)

Take down my banjo
I'll pick it on my knee
This time tomorrow,
It will be no use to me.

You met her on the hillside,
And there, I suppose,
You killed her on the hillside
And there you hid her clothes. (CHO.)

Rings on her fingers
And bells on her toes,
She makes the sweetest music
Wherever she goes. (CHO.)

This time tomorrow,
Reckon where I'll be—
If it hadn't a-been for Grayson,
I'd a-been in Tennessee. (CHO.)

Apart from the stanza about "rings on her fingers and bells on her toes" (which does not appear in the literature and may have been Proffitt's contribution based on the old nursery rhyme "Ride a Cock-Horse"), Frank Proffitt's version appears to be essentially the same as the one recorded by Grayson and Whitter in 1929, with the usual amount of variation that occurs with orally transmitted material (or what is known as the "folk process"). This is not to imply, however, that Frank Proffitt or any of his ancestors learned "Tom Dooley" from the Grayson and Whitter recording. This song was well known in Watauga County, North Carolina, by 1921. It should be noted that the melodies of the two versions are essentially the same.

FRANK WARNER'S MODIFICATIONS OF "TOM DOOLEY"

Frank Warner, a capable performer himself, featured the song in his concerts and presentations for many years. As he says in a 1963 *Sing Out* magazine article: "I used 'Tom Dooley' in every lecture and program, telling the story of Tom—and of Frank Proffitt—and singing my own modifications of Frank's version, having taken the essence of the story and reduced it from six stanzas to four, and—over many years—having reshaped the melody line to fit my own feelings about the song."

Following Frank Warner's 1952 recording of "Tom Dooley," which was the first commercial recording of the song since Grayson and Whitter's release on Victor in 1929, the song was "covered" by several folk revival artists. It was recorded by the Folksay Trio (Erik Darling, Bob Carey and Roger Sprung) on the Stinson label in 1953; by Paul Clayton (as "Tom Dula") on the Riverside label in 1956; and by the Tarriers on the Glory label in 1957.

That was about it for "Tom Dooley" until the Kingston Trio came along and began looking for songs to fill out their repertoire. And here the story takes more twists and turns than the Yadkin River that flows past Tom Dula's birthplace in the hills of North Carolina.

"TOM DOOLEY ON OVERDRIVE"

In the notes that accompany the boxed set of CDs from Bear Family Records *The Kingston Trio: The Guard Years*, the author states that Dave Guard of the Kingston Trio told persons unnamed that he learned the song from the Folksay Trio's 1953 recording on Stinson. Unlike the Kingston Trio's relaxed, calypso-esque version, the Folksay Trio recording of "Tom Dooley" clips along at a much faster pace, driven by Roger Sprung's blue grass–style banjo playing. More important, the Folksay Trio version does not contain the verse about Grayson, which was included in the Kingston Trio version. It is possible, however, that the Kingston Trio learned the basic song from the Folksay Trio recording, slowed down the tempo and added the Grayson verse from the Lomax book.

FOLK SONG: USA

In her book *Traditional Folk Songs from the Anne & Frank Warner Collection*, Anne Warner states, "In 1958, the Kingston Trio used the 'Folk Song USA' version in a recording for Capitol Records."

The text of "Tom Dooley" printed in *Folk Song: USA*, is identical to the one recorded by the Kingston Trio with the exception of a few minor modernizations (in the Kingston Trio version, "tuck" becomes "took"; "stobbed" becomes "stabbed"; "tomorrer" becomes "tomorrow"; "hadn'-a" becomes "hadn't-a"; and, "a-hangin on" becomes "hangin' from"). Another slight difference between the two versions is the tempo: the Kingston Trio's version is slow and relaxed while a performance note in *Folk Song: USA* indicates that the song should be played "Moderately Fast," which is the way Frank Warner (and his source, Frank Proffitt) played it. So if *Folk Song: USA* was not the Kingston Trio's source for "Tom Dooley," it is reasonable to assume that they were at least familiar with it. However, this assumes that the Kingston Trio could read music. And if they were like most folk song performers of the day, they probably could not.

A more likely scenario is that they heard the song elsewhere and then consulted *Folk Song: USA* for additional or alternate lyrics. In any case, the Kingston Trio could just as easily have learned "Tom Dooley" from Frank Warner's 1952 Elektra recording. Warner's version contains all of the verses they used (plus one they did not use and which does not appear in *Folk Song: USA*). What's more, it sounds like the Kingston Trio version,

complete with four-string banjo accompaniment. (The Kingston Trio's usual instrumentation was five-string banjo, guitar and tenor guitar, but on "Tom Dooley" they featured four-string banjo, guitar and tenor guitar.)

As to why Ms. Warner failed to mention her husband's 1952 recording of "Tom Dooley" (or the recording by the Tarriers) as a possible source for the Kingston Trio's recording, the answer may lie in the following statement, which she makes further on in her book: "The only existing copyright on 'Tom Dooley' [at the time the Kingston Trio recorded it] was the one covered by 'Folk Song USA.'" Thus, it appears that her husband's recorded version of the song was not copyrighted. And as we shall see, following the Kingston Trio's enormously popular recording of "Tom Dooley," copyrights became a major issue for all concerned.

THE LEGAL BATTLE

The Kingston Trio were not the first recording artists to claim copyright to material that was assumed to be in the public domain. In the 1920s, Carson Robison, the Carter Family, Jimmie Rodgers and others recorded many traditional songs that they or their publishers copyrighted. Leadbelly, Woody Guthrie and the Weavers did the same in the 1940s and 1950s.

Similarly, folk song collectors such as John and Alan Lomax routinely copyrighted the songs in their published collections. (Pete Seeger, America's best-known folk singer, took issue with his longtime friend Alan Lomax over the idea of anyone owning the rights to traditional material that, he said, belongs to us all. However, this was a bit of double-speak since the Weavers, of which he was a member, copyrighted any number of traditional songs under the pseudonym Paul Campbell.) Be that as it may, a protracted legal battle followed the success of the Kingston Trio's recording of "Tom Dooley," no doubt fueled by the tremendous profits the song was generating, which resulted in an out-of-court settlement in 1962 whereby all subsequent royalties that accrued to the song were to go to Ludlow Music, which represented the interests of John A. Lomax, Alan Lomax and Frank Warner. (It should be noted that according to Frank Warner's article in *Sing Out* magazine, an arrangement was made with Ludlow whereby 50 percent of his share of the royalties from "Tom Dooley" would go to Frank Proffitt.) Apparently, Lomax, Lomax and Warner claimed that the Kingston Trio used the copyrighted *Folk Song: USA* version of "Tom Dooley" for their

Capitol recording. This being so, Ms. Warner no doubt felt compelled to reiterate that claim in her book. In fact, had she suggested that her husband's uncopyrighted recording was a possible source—which, clearly, it was—it might possibly have caused the case to be reopened.

THE LEGEND LIVES ON

Ultimately, it may never be known what the Kingston Trio's exact source or sources for "Tom Dooley" were, especially now that Dave Guard, who handled the majority of the group's song finding, rewriting and arranging chores at the time, is no longer with us. What matters most is that the world has the song now to enjoy—and, no doubt, to further "adapt and arrange" for generations to come. In this regard, Dr. Jerome Epstein, music editor of the Anne Warner book, has something interesting to say: "The song ["Tom Dooley"] is now being sung by Frank Proffitt, Jr., who is sure that he learned it from his father; young Frank's tune, however, is as sung by Frank Warner, not his father."

A photo of Doc Watson, the Grammy-winning guitarist from Watauga County, North Carolina. *Courtesy of Wikimedia Commons.*

Peter J. Curry, who researched much of the material here, is a writer and musician who lives in Palmyra, New Jersey. Among his favorite recordings, he lists the Doc Watson version of "Tom Dooley," which can be heard on the 1964 Vanguard release, *Doc Watson.*

VERSIONS OF "TOM DOOLEY"

Grayson and Whitter, "Tom Dooley," Victor, 1929
Frank Proffitt, "Tom Dooley," field recording by Frank Warner, 1940
The New Lost City Ramblers, "Tom Dooley," 1954
The Kingston Trio, "Tom Dooley," Capitol, 1958
Frank Proffitt, "Tom Dooley," field recording by Frank Warner, 1959
Curtis Hobock & The Stardusters, "Tom Dooley," radio broadcast, Dixieland
Jamboree, Corinth, Mississippi, 1959
Doc Watson, "Tom Dooley," Vanguard Records, 1964
The Sundowners, "Tom Dooley," Bloodshot records, 1967
Steve Earle, "Tom Dooley," Bloodshot Records, 2002
Frantic Flintstones, "Tom Dooley," Anagram Psychobilly, 2003.

Of course, there is a close connection with "The Ballad of Tom Dooley" and the Tom Dooley Museum in the Whippoorwill Academy and Village in Ferguson, North Carolina.

The entrance to the Whippoorwill Academy and Village in Ferguson, North Carolina. *Author's collection.*

The Tom Dula Museum in the Whippoorwill Academy and Village in Ferguson, North Carolina. *Author's collection.*

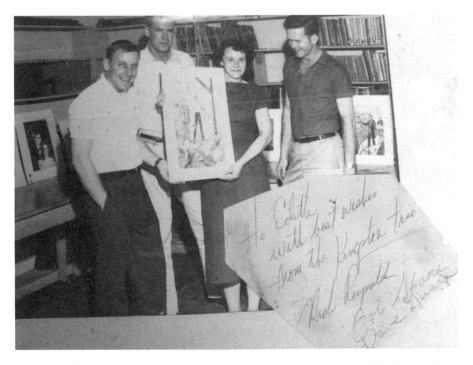

Edith F. Carter with the Kingston Trio at the Tom Dula Museum, circa 1960. *Courtesy of WV/TDM.*

EPILOGUE

After a century and a half, the story of the Wilkes County murder of Laura Foster by Tom Dula is still a story of interest. In 2012, a final marker was placed on the grave of Ann Melton off Gladys Fork Road in the Old Melton Family Cemetery. The descendants of James Melton and Pinkney Foster (Ann's brother) placed the monument or headstone on the grave of Ann Melton. These two men were, respectively, Ann Melton's husband and her older brother. The graves of the other principals in the story, Laura Foster and Thomas C. Dula, had previously been marked, although souvenir hunters have vandalized Tom's headstone, and both his and Laura Foster's markers contain incorrect information. The Eternal Triangle is now complete with markers, but the Tom Dula saga seems to live on. In the previous chapters in this book, I have attempted to complete the true story as much as is possible after the passage of so much time. Many, if not all, of the unanswered questions in Professor West's and other authors' books have now been clarified and answered.

Some questions will undoubtedly remain unanswered for all time. In studying the case for many years, one comes away with a still uncertain feeling about the conduct of the trial and the evidence presented. That feeling is probably generated by the lack of exact transcripts of the actual testimony and the lack of detail in the summaries that were written for review by the North Carolina Supreme Court. There seems to be little doubt on the part of the two judges who conducted the trial that Tom Dula was guilty of the act of murder. The evidence, though circumstantial, seems to rule out all

other possibilities except for the actions of Ann Foster Melton and Thomas C. Dula (aka Tom Dooley). For example, the fact that only Ann Melton and Tom Dula knew the exact location of Laura Foster's temporary grave site implicates them in the murder. Tom Dula was seen going or coming from the location of the Bates Place at the times the murder probably occurred.

The popular view in much of Wilkes County is to deny that Tom Dula actually committed the act of murder and that Ann Melton did the actual killing. Most of that opinion seems to stem from the dislike of Ann Melton by the local residents rather than the actual evidence. If one believes even some of the local gossip and folklore about her and her mother Carlotta (Lotty) Foster, that makes the dislike perhaps justified but does not mean that she committed the murder. Mostly, it seems, both she and Tom Dula were convicted of being immoral and perhaps even depraved individuals, but that was not evidence of criminal activity. Some of that opinion, with perhaps some truth, stems from the fact that Ann's mother, Carlotta "Lotty" Foster, was reviled in the community for a number of reasons. Local folklore was that she was a depraved and drunken individual who continuously gave birth to illegitimate children, both black and white, and that she disposed of the black children.

The truth appears to be somewhat different. She did have several children, eight of whom are known, but she was actually married to a man named Francis Triplett. Francis Triplett was the son of Martin Triplett and Nancey Brown. His parents' marriage ended in divorce and lasted only about two years. He lived with his father as a child, but not much else is known about him. Carlotta's mother was also a Triplett, but it is not known if her husband and her mother were distantly related. Carlotta was living with her mother-in-law's family during her early married years, about 1840 to the 1850s, and all of her children up to about 1858 were given the Triplett surname. Her husband was not listed in that household in 1850. Sometime between 1850 and 1860, something happened to Francis Triplett. He may have abandoned his family, perhaps to join in the 1849 gold rush, or, as was rumored in the settlements, she may have killed him. Whatever happened, it must have been a traumatic event for Carlotta and her family because she reverted to her maiden name of Foster and changed all the children's surnames from Triplett to Foster. It appears from the scant records and from the settlement folklore that she may have become an alcoholic and may have had at least some illegitimate children. However, she continued to use the Triplett surname as a given name for some of her children, perhaps implying a continuing connection with her missing husband.

That kind of family life must have affected, but did not excuse, the outlook on life that Ann Melton developed as a child. On the other hand, Carlotta had testified that she had chased Tom Dula out of Ann Melton's bed and home when she found them together after Ann married James G. Melton. That seems to suggest more of a moral character than has been attributed to her in the local folklore. As for Anne, being the outstanding local beauty probably promoted her entitlement attitude and the envy of others her age. The *New York Herald* reporter and others remarked at length about her beauty and confident bearing. At her arrest, she reportedly said, "A rope will never go around this pearly white neck." The following appeared in the *New York Herald* on May 2, 1868:

> *She is apparently about twenty-five years of age, is the illegitimate daughter of one Carlotta (Lotty) Foster, and is a most beautiful woman. She is entirely uneducated, and though living in the midst of depravity and ignorance has the manner and bearing of an accomplished lady, and all the natural powers that should grace a highborn beauty. This may in part account for the great influence she obtained over Dula, with whom she is illegitimately connected, and also for the fact that he presently denies all knowledge of her participation in the murder.*

An old man from Wilkes County, North Carolina, said:

> *Ann Melton was the purtiest woman I ever looked in the face of. She'd a-been hung too, but her neck was jist too purty to stretch hemp. She was guilty, I knowed hit...Ef they'd a-been ary womern* [if there had been any women] *on the jury, she'd a-got first degree. Men couldn't look at the womern and keep their heads.*

Clearly, Ann's beauty affected those around her, but why she had such disdain for work is unclear because her mother obviously worked hard, had property and a home and managed to survive without a husband in her household. Ann, on the other hand, found herself having to provide for and care for a small child and her husband's farm after he enlisted in the Confederate army at the very beginning of the Civil War. Perhaps James needed to get away from her demanding ways, contributing to his early enlistment. James Isbell had tried to enter testimony as to her promiscuity and infidelity during the two trials, but no real evidence to support his charges was recorded. Other rumors were that both Ann and her mother

had engaged in prostitution to survive during the Civil War years. Again, no recorded testimony supports those rumors.

John Foster West raised the question of "What kind of man was James Melton, who seemed cowed by Ann and would not openly question her behavior and attitudes?" On the other hand, James Melton was known to have been a brave and gallant soldier during his service in the Confederate army, and he was well liked and admired in the community. It was known that he would "fight anyone" who had anything "bad" to say about Ann. The evidence is that he was also fond of Tom Dula, perhaps because he was a childhood friend of Ann's and James had known him all his life. It was James Melton who had warned Tom that he was about to be arrested in the disappearance of Laura Foster. Perhaps it was enough for James to have Ann as a "trophy wife," even if he had to share her with Tom Dula. Some writers have tried to imply that he was impotent after the war, which could explain why he did not sleep with his wife. That claim is easily discredited because he fathered one additional child with Ann after her release from jail, and then, after Ann died, he fathered three additional children with his second wife, Louisa Gilbert.

In studying the trial testimony summaries, one raises several questions that do not directly bear on the guilt or innocence of those charged in the murder. For example, why was Ann Melton not afforded bail? She was not charged with murder and had means and ties to the community. She was not a flight risk, so why was she kept in jail for the two years of the trials? Part of the reason may have been the change of venue and the difficulty of having the witnesses show up for the scheduled trials, but it does seem strange that she was denied bail.

Another speculation about the events of Friday, May 25, 1866, was that Tom Dula might have taken liquor to Laura Foster at the Bates Place and gotten her inebriated so she would stay there until he returned for her. However, the canteen of whiskey from the Thursday evening before was found where Ann and Tom had left it, and it still contained some liquid, so that container of moonshine was not taken to Laura Foster. That Laura would have waited at the Bates Place for Tom for eight to twelve hours without food or water also seems very unlikely.

Another apparent question is: why was Eliza Dula not asked to testify about Tom's whereabouts on the morning of May 25, 1866? She could have provided him with an alibi for at least the morning of that day if she were home when he arrived there. He had gotten milk from Lotty Foster on his way home that morning. Did he take it to Laura or did he take it to his home?

Another common folklore in the Wilkes community is that Ann Melton and Tom Dula met on the Stoney Fork Road sometime in the early morning of May 26, 1866, and transported Laura Foster's body from the Bates Place to its hiding place on what is now Laura Foster Ridge, burying it in the makeshift grave on the ridge above the Dula home. That scenario was implied by Pauline Foster's testimony in the undated transcripts in the trial documents. In those documents, Pauline Foster was relating a conversation she had with Ann Melton on the morning after Laura Foster's disappearance. Ann supposedly told Pauline that "she had done what she said"; that is, she had "killed" Laura Foster or "had gotten rid of her." Pauline said that Ann told her she had slipped out after everyone had gone to sleep, and no one had seen or heard her leave and return. Ann did not testify, so this testimony was not included in the trial summaries. Besides, such testimony was not admissible under the charge to the jury and was not relevant to the trial verdict since Ann was not on trial at that time.

Is the scenario in this testimony even plausible? There were several people sleeping in the Meltons' one-room home that evening besides Ann Melton. Among them were Pauline Foster, James Melton, Thomas Foster, probably Jane Melton and possibly Will Houlder (Holder). Wilson Foster had gone across the Reedy Branch to Francis Melton's home for the night, probably because there was no extra bed or place for him to sleep at James Melton's. Could Ann have gone out during that night and returned later without being heard or seen? It seems possible only if all of the others were quite drunk by bedtime. However, Pauline and Thomas Foster were up until past midnight talking and then went to bed. Ann Melton and Tom Dula would have needed several hours to meet, collect the body, bury the body and then return to their respective beds. This activity would have taken place after 12:00 a.m., during a dark night, in snake-infested, wooded hillsides—and then the two of them would have had to return to their homes without getting dirt or Laura's blood on their clothes and without awakening anyone in either of their households. Pauline Foster testified that Ann was there in the morning, and there was no mention of any soiled clothing or any other activity during the late night.

Why would Laura Foster wait at the Bates Place while Tom went home to eat and sleep, not knowing when he would return for her? In addition, Tom Dula's mother testified that Tom had removed his clothes and gone to bed late that evening, and at times during the night she heard him moaning and had looked in on him. Could she have missed him during the morning hours before dawn? Neither she nor her daughter Eliza mentioned Tom being

missing during this time period. Tom was there at breakfast, and there was no comment or report of any soiled clothing. The evidence suggests that the folklore account of that evening seems highly implausible.

Could Ann Melton have committed the murder by herself? From the evidence presented, her opportunity to commit the murder of Laura Foster was very limited. She would have had to leave her cabin undetected, after midnight on May 25, 1866, and go to the Bates Place. There she would have had to find and murder Laura Foster in the dark of night, move Laura's body a half mile or so down the ridges to the pre-dug grave, bury the body and conceal its location and then return to her cabin without being seen or heard and without soiling her clothing. That scenario seems almost impossible in the time available to her.

The most logical account of the murder is that it took place either between 10:00 a.m. and noon on that Friday morning or, at the latest, about 6:00 p.m. in the evening, and the body was later buried just after sundown when Tom Dula went out for an hour or so after dark. The conclusion is also that Tom Dula's confession that "he alone had any hand in the murder of Laura Foster" is correct in that he alone committed the *actual* murder and buried the body. However, it is also correct that he confessed to the murder itself to, in part, protect and absolve Ann Melton of complicity in the murder, even though the evidence is overwhelming that she was both involved in planning and inciting Tom Dula to commit the murder. In that sense, she was involved in the crime and should have been convicted as an accessory to murder. Her two years in jail while awaiting her trial were a very light sentence for her complicity in the crime.

Other questions arise about the truthfulness of the trial testimony. It seems clear that Tom Dula's statement before he was hanged—that some of the witnesses had lied about him in their testimony—was probably true. In particular, James Isbell either lied or slanted his testimony about the murder. He said no other males had gone off from the community when Laura Foster disappeared, while others said several other males had become scarce after Laura disappeared. Isbell was so intent on ridding the community of Tom Dula and Ann Melton that he helped pay for the legal costs of the prosecution. He stated in court that he had no use for the defendants but only had the "good" of the community as his motivation. His testimony about the mattock marks on the side of Laura Foster's grave was an attempt to connect Tom Dula to the crime, but those remarks were not supported by any of the other witnesses who were at the scene when the body was found. He also tried to inject character testimony about Ann Melton into Tom's

trial, but the defense had objected. James Isbell's intense interest in finding Laura Foster's killer, in addition to seeing justice done, can be attributed to the fact that Wilson Foster, Laura's father, was a tenant farmer on some of his land, and he undoubtedly knew the Wilson Foster family quite well.

A second witness who gave questionable testimony was the principal witness, Pauline Foster. She was actually a second cousin of Tom Dula and had admitted to being fond of him. Much of her testimony seemed more inclined to implicate Ann Melton and indirectly or perhaps even reluctantly to implicate Tom Dula. As described above, some of her testimony in the loose papers is certainly questionable, if not an outright lie. By the time of the trial, in October 1866, Pauline had finished her summer's work with the Meltons and likely had returned to her home in Watauga County. She was no longer under the influence of Ann Melton and was free to tell what she knew about the events of the 1866 summer.

It is clear that her relationship with Ann Melton was not a friendly one because of the way Ann had treated her during the summer, and she was not very happy that Ann had involved her in her animus toward Laura Foster. The prosecution must have arrived at the same conclusion because that testimony

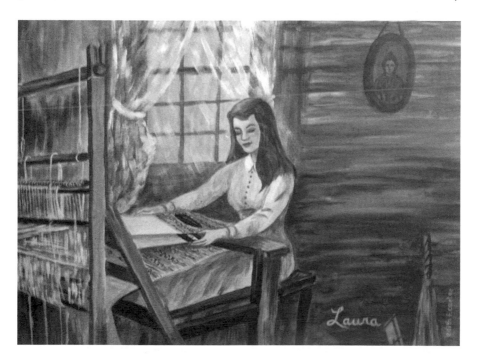

Edith F. Carter's illustration of weaver Laura Foster operating a loom. *Courtesy of WV/TDM.*

was not mentioned in any of the trial summaries. It seems clear that, though illiterate, Pauline had a certain respect or even fear of testifying falsely under oath. She mentioned having been "sworn twice" when questioned about her testimony. On the other hand, she was intent on not being charged with involvement in Laura Foster's murder. Her deal with the prosecution was never spelled out, but it is certain that some accommodation was made.

Ironically, Tom Dula and Ann Melton could have committed the perfect crime, but as in most crimes, they made fatal mistakes. If Tom had released Wilson Foster's mare from where it was tied at the Bates Place, the mare would have returned to its home, and most of the local people would have just assumed that Laura had run away with someone, never to return to the community. Her reputation would have supported that supposition, and they probably would not have looked for her.

Local people who remembered the principals in that case described Laura Foster as "very beautiful…with chestnut curls and merry blue eyes, [but]…wild as a buck."

Wilson Foster would have had his mare back and would have believed that his daughter had just run away with someone unknown. Without the horse's dung spots and the broken rope found at the Bates Place, the location of the murder might never have been found.

The second mistake was Ann Melton's confiding in Pauline Foster that she knew Laura Foster had been killed and that she knew the location of her grave. When she took Pauline near to where the grave was located, that was the link the authorities were seeking to tie someone to the missing girl's demise and to finally locate her body. Without that information, the grave might never have been found, and the community would have just assumed that Laura Foster had run away. Tom Dula would still have been the prime suspect in her disappearance, but without a body or other forensic evidence, the authorities would have had to release him from jail, and he would not have been tried for Laura Foster's murder.

In conclusion, despite the numerous errors, misconceptions, questionable evidence and conflicting testimony, the juries, the judges and the North Carolina Supreme Court came to the correct conclusion. With the possible exception of Ann Melton's acquittal, they got it right!

BIBLIOGRAPHY

MAJOR SOURCES

Absher, Mr. W.O., ed. *The Heritage of Wilkes County North Carolina*. Winston-Salem, NC: WGS Inc., Hunter Publishing Co., 1982.

Arthur, John Preston. *A History of Watauga County*. Richmond, VA: Everett Waddey Co., 1915.Brown, Frank C., ed. *North Carolina Folklore*. Vols. 2 & 4. Durham, NC: Duke University Press, 1952.

Barefoot, Daniel W. *Haints of the Hills*. Vol. 3. Google Books.

Casstevens. Frances H. "Who Murdered Laura Foster?" In *Death in North Carolina's Piedmont: Tales of Murder, Suicide and Causes Unknown*. Charleston, SC: The History Press, 2006.

Dowd, Clement. *Life of Zebulon B. Vance*. Charlotte, NC: Observer Printing and Publishing House, 1897.

Gardner, Rufus L. *Tom Dooley: The Eternal Triangle*. N.p.: Gardner Enterprises, 1960.

Hayes, Johnson J. *The Land of Wilkes*. N.p.: Wilkes County Historical Society, 1962.

Land, Thomas C. "The Murder of Laura Foster." (1866). In *Tom Dooley: The Eternal Triangle*. N.p.: Gardner Enterprises, 1960.

McNeil, George F. *A Transcript of Wilkes County School Census, 1840–1850: With Comprehensive Index of Names and Places*. Wilkesboro, NC: G.F. McNeil, 1993.

The National Museum of Civil War Medicine
48 East Patrick Street
Frederick, MD 21705
http://www.civilwarmed.org

Rucker, James "Sparky." "The Story of 'The Ballad of Tom Dooley.'" *Appalachian Heritage* 36, no. 1 (Winter 2008): 49–53.

Smelling, Curtis, ed. *The Heritage of Watauga County North Carolina*. Vols. 1 & 2. Winston-Salem, NC: Southern Appalachian Historical Assn., Hunter Publishing Co., 1982.

Wellman, Manly Wade. *Dead and Gone*. Chapel Hill: University of North Carolina Press, 1980.

West, John Foster. *The Ballad of Tom Dooley*. Boone, NC: Parkway Publishers, Inc., 2002.

———. *Lift Up Your Head, Tom Dooley*. Asheboro, NC: Down Home Press, 1996.

INTERNET SOURCES

Ancestry.com. Census, Military and other Records. http://www.ancestry.com.

Crouch, John. "Historical Sketches of Wilkes County, 1902." http://archive.org/details/historicalsketch00crou.

Curry, Peter J. "'Tom Dooley': The Ballad that Started the Folk Boom." http://www.kingstontrioplace.com/tdooleydoc.htm.

Family Search. www.familysearch.org.

"Going Home for History." Wilkes County, North Carolina. http://www.fmoran.com/wilkes/dula.html.

Katzman, Mary Floy. "The Capture of Tom Dooley." http://jctcuzins.org/stories/dooley5.html.

Slade, Paul. "Infectious: Tom Dooley." http://www.planetslade.com/tom-dooley01.html.

"Tom Dooley: The Legend and the Facts." http://www.kronsell.net/tom_dooley_the_legend.htm.

NEWSPAPER SOURCES

Alexander, Nancy. "Tom Dooley." *Lenoir News Topic*, 1959.

Dispatch, October 26, 1866.

Gilliland, Kim. "Family of Anne Melton, Part of Tom Dula Legend, Mark Her Grave with New Headstone." *Lenoir News-Topic*, February 25, 2012.

Hubbard, Jule. "A Bit of Justice for Anne." *Wilkes Journal-Patriot*, February 24, 2012.

Isbell, Rev. R.L. "The World of My Childhood." *Wilmington* [NC] *Daily*, 1955.

Lankford, Jerry. "Dooley Pardon Denied." *The Record*, January 14, 2009.

McClung, Marshal. "Dooley Legend Lives as Group Seeks Pardon." *Graham Star*, 2008.

New York Herald. "The Death Penalty, Shocking Revelations of Crime and Depravity in North Carolina—Thos. Dula Hanged for the Murder of Laura Foster." May 2, 1868.

Old North State, May 8, 1868.

Salisbury Watchman, May 8, 1868.

Statesville American, November 5, 1868.

CASE FILES

The original case files from the Supreme Court cases are archived in the North Carolina State Archives in Raleigh, North Carolina. The online copies are accessible via www.FamilySearch.org. The papers from the first appeal to the Supreme Court are available in Case 8922, starting with image 214 and ending with image 281. The second appeal is Case 8923, starting with image 282 and ending with image 335.

ADDITIONAL SOURCES

Ferguson, Thomas W., and William H. Ferguson. *History of the Ferguson Family of Watauga County, NC*. Self-published history, June 1955.

Foster, Tony. "Foster Genealogy Records." Personal communication.

Madron, Daphne. "Melton and Gilbert Genealogy Records." Personal communication.

Melton, Edith. *A Melton History*. Self-published history, n.d.

Monroe, Wayne. "Dula and Triplett Genealogy Records." Personal communication.

FICTIONAL VERSIONS (BASED ON FOLKLORE AND SOME DETAILS OF THE TOM DULA SAGA)

McCrumb, Sharyn. *The Ballad of Tom Dooley*. N.p.: Thomas Dunne Books, 2011.

Reynolds, Karen Wheeling. *Tom Dooley: The Story Behind the Ballad*. N.p., 2002. [A novel.]

————. *Tom Dooley: A Wilkes County Legend*. [Play performed annually in Wilkesboro, North Carolina, since July 2000.]

————. *Tom Dooley: A Wilkes County Legend*. Bristol, VA: Little Creek Books, 2011. [A novel.]

Index

About the Author

Dr. John E. Fletcher is a retired research scientist and former professor of mathematics. Although he grew up in Watauga County, North Carolina, and personally knew many of his relatives in Wilkes County, North Carolina, he was unaware of his personal connections to the Tom Dula saga until later in life. Dr. Fletcher holds degrees in engineering and applied mathematics from the North Carolina State University and a doctor of philosophy in applied mathematics from the University of Maryland. He worked for Lockheed Aircraft and the National Institutes of Health during his career and also taught mathematics in a number of colleges and universities during his working years. He authored or coauthored over fifty scientific articles and reports during his career. Since retiring, he has authored a number of genealogical articles for historical journals.

Both before and after retiring from active employment, he occupied his spare time by engaging in genealogical research on his family's roots. He first

encountered the Tom Dula story when a first cousin read some of the trial records while researching their common family ancestors in Wilkes County, North Carolina. The many conflicting versions of the story motivated Dr. Fletcher to apply his research skills and genealogical knowledge to determine the true facts of the Tom Dula saga. After years of detailed research, Dr. Fletcher has not only determined what can be known about the true story but has also solved most, if not all, of the remaining mysteries about the murder case, and he has identified who its many participants really were. The mythology and folklore are cleared away, and the true story is established with the facts from the remaining records. Eyewitnesses have claimed that some of the murder participants still roam the Reedy Branch hills and ridges near where the murder took place. Perhaps now, with their true story revealed, they can finally rest in peace.